NEW MARKETS FOR ARTISTS

How to Sell, Fund Projects, and Exhibit Using Social Media, DIY Pop-Ups, eBay, Kickstarter, and Much More

Brainard Carey

ALLWORTH PRESS
NEW YORK

Allworth Press books may be purchased in bulk at special discounts for sales promotion, corporate gifts, fund-raising, or educational purposes. Special editions can also be created to specifications. For details, contact the Special Sales Department, Allworth Press, 307 West 36th Street, 11th Floor, New York, NY 10018 or info@skyhorsepublishing.com.

15 14 13 5 4 3 2

Published by Allworth Press,
an imprint of Skyhorse Publishing, Inc.
307 West 36th Street, 11th Floor, New York, NY 10018.

Allworth Press® is a registered trademark of Skyhorse Publishing, Inc.®, a Delaware corporation.

www.allworth.com

Cover Photograph by Richard Bolger

Library of Congress Cataloging-in-Publication Data is available on file.
ISBN: 978-1-58115-913-4

Printed in the United States of America

This book is dedicated not only to my wife, who is my partner in all endeavors, but also to the woman who is my muse and inspiration, and who happens to be the person I am married to. I am lucky to be with her, and this book is one of the things that could not have been done without her. In a word, I am lucky *because* of her.

Contents

Acknowledgements

The reason I wrote this book was in answer to the many artists who receive my newsletter, The Art World Demystified. It is also for all those who continue to seek my services as a coach to help with building a strategy for their career.

It has been incredibly rewarding for myself as a professional artist and coach to work with individuals whose career took a turn for the better after focused commitment. I want to thank all of you who have been a part of the newsletter and all of those who may be part of it in the future. Much of the information on the web site, http://yourartmentor. com, was designed for artists and is regularly updated with feedback I remain grateful for.

My wife Delia Carey, is half of everything I do with The Art World Demystified, and though I am the "talker" so to speak, we run this educational resource together, and without her, it would not exist. I remain grateful for her beyond measure but in the case of this book, she has also been an excellent editor and source of encouragement and love. :)

My father, Marvin Salzberg has been a great support and continues to be as my late mother, Joan Egeland-Scott was.

When I interview artists I often ask about their parents, and it is usually no coincidence that one of the hardest professions on the planet had some real love and support behind it in the form of parents. Of course that is not always the case, but in mine it was. I miss my mother tremendously and wish she could have seen my first book published, but I know that her voice is in the words I write throughout this book.

My son, Shiva Carey has also been a great supporter of my work, and while that might seem natural, he has the insights of a writer at a young age and it has served me well. Also his ability to teach me about games like Portal, Mortal Combat and Assasins Creed, has allowed me to understand the immense power and artistry of the video gaming industry, largely built by visionary artists. Without him, I would be at a loss to understand it all, and of course without him, I would not be having nearly as much fun playing all the games I do.

Skyhorse Publishing has been a pleasure to work with, and in an age of electronic books, they are a publisher who still makes beautiful books, with special attention to cover art, paper stock and the general beauty of the printed book. How can I not love them?

Richard Bolger, longtime friend and excellent photographer, created the cover photograph for this book and the last one, and without him, I believe this book would not be nearly as sexy as it it. Thank you Rich.

Thank you for reading this book, I am grateful that you bought it! My policy has always been to return the favor by answering any of your questions through my website, http://yourartmentor.com, and yes, I am a busy person, but always have the time to return an email. Thank you.

Introduction:
Is This Book for You?

If you are a serious artist in midcareer, or just thinking about taking a first professional step in the arts, this book will help you identify which market in the art world might suit you best. It will also explain how to reach it, with a focus on social media strategies.

Traditional and Nontraditional Markets

This book will discuss traditional markets and exhibition opportunities such as art fairs, art consultants, galleries, and museums, but the emphasis is on the Internet and using new social media tools to network and get exposure for your art. For the reader who already uses Facebook, Twitter, Instagram, or Google Plus: this book will help you to turn that knowledge into a directed, easy-to-manage, and savvy campaign. And for

the reader who is reluctant to use Facebook and Twitter, this book can serve as a beginning course to help you familiarize yourself with these platforms and come to enjoy them at your own pace.

Where You Fit In

If you are a painter, sculptor, or conceptual artist, you will benefit from this book's lessons on how to use the Internet to advance your career. You will hear stories of artists who have had success in selling their work on their own terms, without compromising in any way. You can choose which story or combination thereof fits you. If something clicks and one of these stories shows you a career path you'd like to emulate, then the remainder of the book will fill you in on the details. In the following chapters, the method you choose will be broken down into steps which you will use specific tools to complete. There is much devoted to Internet strategies, for the beginner as well as for the advanced user. I will also discuss other non-digital methods, such as new satellite art fairs around big ones, and making your own pop-up shows to selling on the street. The Internet is truly the new territory, through which you can access billions of viewers. Even in the midst of economic crisis, there is a growing online market for art. It is a new territory because the Internet is vast and growing with more viewers all the time. In Asia alone there is over 900 million online, and in Europe, there is 500 million and in North America, almost 300 million as of 2012.

Artists living in the new millennium must create new models for exhibitions and sales. They must also be aware of new modes for reaching an audience, including social

networking, the latest online platforms, and mobile phone apps. How we share visual information is radically shifting, and artists can use all these new tools.

> *If you are a painter, sculptor, or conceptual artist, you will benefit from this book's lessons on how to use the Internet to advance your career.*

Cutting Edge

In the hyper-competitive world we are in, the latest software and hardware, as it applies to creativity and promotion, is part of a language in which you must be conversant. This book is like a language course, in that it is meant to enhance your ability to communicate your art and creative ideas to the world. It is also a map, a strategic guide, to help you plant your ideas in the right soil so they will grow. That soil is the physical world as well as the virtual one.

Education

This is my second book on professional development for artists, and it can be used as a companion volume to the first one, *Making It in the Art World*. What is different about this book is that in it I focus primarily on the Internet as the main "new market" for artists. It is a territory that continues to grow rapidly, and has already provided artists with a full-time living. In chapter 6, I will talk about a graffiti artist who had a background in graphic design, working for an ad agency, and then quit his job to sell his art, first on the street and then on the Internet. When I interviewed him he said his thinking was that it didn't make sense for him to look for a gallery, even in his hometown of New York City, because there were

a billion potential customers out there on the Internet. That is the realm of new markets—how can you argue with his thinking? He is right. That does not mean that galleries no longer have their place. In fact, TMNK, the artist who sold his work on the street, also had several sold-out gallery shows in Europe, and those galleries found him through work he displayed on the Internet and on the street.

Sharing Efficiently, The Good News

What this means for artists is that there are more opportunities than ever, and there are more ways to raise money and put together shows through the new world of social networks, which continue to grow, enabling us to share more and more information. As an artist, that is what you are doing: you are sharing information, sharing your images and ideas. And that is what a participant, an artist in the new world market, has to become an expert in: the means to share efficiently.

Organizing

The problem for many is how to manage all that information. Which news source do you read, which blog do you read, and where do you see art? Where do you read reviews about art? Rather than get overwhelmed or remove yourself from civilization—which now means being connected to the Internet—we must all organize ourselves so we can manage our careers efficiently without getting too busy or spending valuable studio time in front of the computer. If you followed all the tools and techniques in this book, and carried them all out with a passion, you could limit yourself to as little as thirty minutes a day online. If you wanted to do more, you could

spend up to two hours online developing your career. Either way, I am not asking you to spend more time on the computer; I am trying to get you to spend less time in front of a screen by making the time you are there as efficient as possible.

Full-Time Income

In chapter 6 I tell the story of an artist who sells all her work on eBay. She makes a full-time living at it with a six-figure income. She spends about two to three hours a day on eBay, blogging, and posting her latest work. As of this writing, she has become so successful after about three years of hard work that her art is now sold by other sources, like a gallery that saw her selling art online and made her a deal of some kind. You see, it is not just about you sharing and selling directly, it is about you becoming known as a successful artist, or as an artist with great work; then other people will make you offers that you may not have expected. There are stories of many bloggers getting a book deal based on the writing they are doing daily. In fact, the way I started publishing was not by submitting a book proposal to a publisher. It was the publisher that called me, because he saw my newsletter, or a friend of his saw my newsletter and suggested he contact me. That happened within less than a year of starting a newsletter, and it led to four book contracts.

Momentum

Things tend to snowball once there is momentum. In 2011, I was writing books like this one and two others as well. I also created an Internet project on kickstarter.com and I raised thousands for an art project I was doing. But that online art project led to many more things. I was invited to have a show with my wife in

New York, and I was invited to a biennial in Europe (all expenses paid)—and more opportunities kept coming! I have been at it for many years as an artist, but the reason that 2011 was such a big year for me was also because I was firing on all cylinders, I was organized, and I was using all of the social media tools available, from managing my mailing lists, to Facebook, Twitter, and blogs. In this book I will tell you how to efficiently utilize all those tools and customize them for yourself to fit your pace, your goals, and to make your life easier and more productive with the least effort. I welcome your comments and suggestions because they are the basis of much of the information in here. I write a newsletter—which I encourage you to subscribe to—and in it I update all the information that I talk about in this book. In fact, in chapter 2, I base my writing on an answer to a letter from an artist. My website is yourartmentor.com.

Chapter 1

Prospering in the New Marketplace

Before this book entered production, the editor asked me to include more stories in the first chapter showing how specific artists used a social networking tool like Facebook to their advantage. A few short examples of what artists have done for their careers through Facebook are outlined here so you can see how it might work for you. To research these stories, I posted a paragraph on my Facebook and Google Plus accounts asking if artist friends had stories to tell about social media tools and connections helping their art career. I got many responses from friends. Here are a few I think worth sharing.

The Jerry Saltz Page Phenomenon

On Facebook, there is a well-known New York art critic, Jerry Saltz, who has a page that anyone can read. It is a place where

> *Occasionally, Facebook comments turn into offline exchanges that can become very real.*

hundreds of artists debate and meet each other. The friend limit has already been reached on that page, but Saltz is also on Twitter and other media, and he frequently deletes massive amounts of friends to make room for new ones!

P. Elaine Sharpe

P. Elaine Sharpe is an artist from Toronto, Canada, who frequents the page and often makes comments that are interesting enough to generate more debate and sometimes responses from the critic himself. Occasionally, comments turn into offline exchanges that can become very real. In 2011, Savannah Spirit, a curator who met Sharpe through Jerry Saltz's Facebook page, put some of Sharpe's work in a show called Hotter Than July, in NYC. That show got press, and was listed as a "Critics Pick" in *New York Magazine* as a show to see. The critic, of course, was Jerry Saltz. His use of Facebook is better than most, because as a writer he creates wonderful short phrases, often misspelled, seemingly in a rush, that are engaging, charming, vulgar, and thoughtful, and that generate tons of responses. He is truly communicating with his audience, as opposed to just making announcements about his latest interests.

Lindsey O'Leary

Lindsey O'Leary was working in a museum to help market exhibits. She said that in October of 2010 she tweeted a couple of times at Robin Cembalest, editor of *ARTnews*, and it resulted in a review of the Mattress Factory's "Queloides: Race and Racism in Contemporary Cuban Art" exhibition in 2010.

She went on to say, "From that moment forward, I believed in the democratic nature of social media." That is a small amount of effort to put in to gain a major review, and it points to the ease of personal tweets to gain press attention worth thousands of dollars. www.mattress.org

Jill Slaymaker

Jill Slaymaker is a fifty-six-year-old artist who started using Facebook in 2010. She uses it to build her résumé and get exhibits. She said Rolando Ramos contacted her on Facebook saying he was curating The Chakra Show at the Mary Benson Gallery in Jersey City, which she was eventually included in. Also, while looking through Facebook and seeking opportunities for exhibits she saw an open call for the Tate Modern in London. She submitted work and was accepted into a group show there curated by Ceci Moss. For her, Facebook is also a way of meeting new and interesting people. There was a museum in Barcelona that invited her for a solo show, and that turned out to be a glass phone booth, which was a conceptual project by another artist, but it was real and a lot of fun to be part of, for her. She continues to exhibit and build her career by looking for opportunities, but also by chance happenings that come from getting out there and meeting people. www.jillslaymaker.com

Terri Loyd

Terri Loyd, artist, fifty years old, uses Facebook to build a community of artists that share similar interests for mutual gain. She created an organization called The Haggus Society. After meeting in person with Deborah Forbes, an artist and friend from Facebook, Loyd convinced her to become a member of

Sandy Tracey sells a painting at least once a week and has a growing base of fans.

the Haggus Society. In the Spring of 2010 Loyd launched the society as a nonprofit and began gathering more members. Within a year she has thirty-eight local members and eighty-eight worldwide. As a group, they share work, create exhibits, and increase visibility for women artists over forty years old. As the site says, "The Haggus Society strives to redefine the conventional terminology of emerging, mid-career, and late-career artists as classifications and barriers to accessing support."Her use of Facebook has enabled her to meet new members, through Facebook and grow her organization, and also simply to meet more artists who feel the same way she does._www.thehaggussociety.org

Sandy Tracey

Sandy Tracey is fifty-eight years old, has a background in graphic design, and started a blog where she posts a painting every day. She spends about ninety minutes every morning painting a small work, about five by seven inches. Then she photographs it with her small consumer camera, and posts it on her blog. The blog also automatically posts it to her Facebook page. At first she asked for $50 for each painting, but they weren't selling, so she dropped the price to $30, and people bought them. Sandy said she did whatever the blog instructions said to do to promote your blog, like using Twitter and commenting on other peoples' posts. She also started to write more and to tell people she was saving up for a trip to Greece, and that seemed to increase sales for her. Now she sells a painting at least once a week and has a growing base of fans. www.sandytracey.com

Abbey Ryan

Abbey Ryan is discussed in detail in chapter 6, but she began the same way Sandy Tracey did, and after less than three years of posting her small paintings on eBay every day, she was earning over $200,000 from her work. Like Tracey, she began with low prices, and the prices slowly grew until she was selling a small painting for about $800 every day. There are more and more artists selling this way from all over the world, and eBay is a market that builds real value, because as demand grows, the prices will naturally be bid higher.

While Abbey Ryan is a big success, it is important to see that it isn't all or nothing. Sandy Tracey is also selling her work and isn't looking for a full-time income—just a way to earn a little extra income. www.abbeyryan.com

Kim Jacobi

Here is the story of Kim Jacobi, an artist who used Craigslist and Facebook to jumpstart her career. In her own words:

> I am a textile and batik artist living in Southern California. Although I created a batik over twenty years ago as an assignment in an interior design class, I started rather late as an "artist" (I was over fifty when I again picked up fabric, wax and dyes). Convinced by family and friends that I should try to market and sell my art, I felt I had no time to waste. I started looking at Craigslist ads under Community and Artists at least twice a day and answered every "call for art" I saw. I've shown at over thirty one-night art shows, have been involved in three

monthly art walks and two community art fairs, and am now hanging in one art gallery and one clothing store, both on Abbot Kinney Boulevard in Venice, CA, which has turned into a world-renowned shopping mecca. All of this has happened in under a year. I am now coordinating a series of modern batik art workshops with master batik artist/instructor, David Kibuuka, here in L.A. I reached him by just sending him an email telling him how much I admired his work and explaining what I do, how I started, and how I evolved, and including a link to my website. I told him I'd appreciate any comments. Well, he wrote me the very next day saying he loved my work and wanted to learn my process, and that we should collaborate on some project and he would come here to do it. I was having a hard time finding a suitable location at a reasonable price until I posted a "shout out" on a Facebook page called SoCal Art Shows & Events. I found the perfect spot. The workshops are set to go forward in October and I have already had sixteen people respond to flyers I had printed as well as another post on the same Facebook page. So I'm a big advocate of Internet networking. It's been working for me.

For Kim Jacobi, Craigslist and Facebook brought the majority of her opportunities, along with old-fashioned ambition and dedication to her goals. She started like everyone else, not knowing what Facebook is even about, and before long it was a comfortable tool in her hands. http://badassbatik.com/

Katherine Boland

Katherine Boland also has a fantastic Facebook story. She says:

> *"Facebook has dramatically changed my life and the consequences of this Facebook connection have been far-reaching and continue to influence my career."*
> — Katherine Boland

I am a professional Australian contemporary artist living in Melbourne, Australia. I had only been a member of Facebook for two months and had become Facebook friends with an artist in Pakistan. This artist was invited by the Ministry of Culture in Egypt to participate in an international artist's symposium in Luxor, Egypt. The Ministry of Culture asked her if she knew of any international artists who would be suitable to submit a proposal for participation in the symposium. She put my name forward and I subsequently submitted an application which was reviewed and accepted by the symposium committee. I flew to Egypt in November 2010. I produced and exhibited a body of work during my time in Luxor using locally sourced materials such as palm trees, papyrus, desert sand, mummy bandages, lime stone, and encaustic. As an aside I met and fell in love with an Egyptian man whilst in Egypt and have been back there twice since November. During one of my visits I was asked to participate in a biennial in Turkey. I made the work in Cairo and flew to Istanbul to deliver it. That work is now in a gallery in Istanbul. As you can see, Facebook has dramatically changed my life and the consequences of this Facebook connection have been far-reaching and continue to influence my career.

Isn't that an amazing story? One of the wonderful things about artists using Facebook to create connections and opportunities is the possibility of chance happenings and unintended meetings. Unlike the typical decision-making paths we follow in life, the Internet allows multiple possibilities from all over the globe to take shape at once. That may sound overwhelming, but it actually results in surprises that can make all the difference in life. www.katherineboland.com

Terry Marks

Terry Marks found a niche through networking and then Facebook that inspires her to create and share. She said:

> I'm a figurative painter living in New York City, who had for some years been discouraged by the extreme lack of representational painting in the gallery system, when, in the summer of 2001, I heard a radio piece on NPR about a new arts group called the Stuckists. I listened with interest as they talked about themselves as painters who felt the same way I did and also about their group, which they referred to as "Remodernist." I looked up their website, contacted one of the founders, Charles Thompson, and began the NY chapter of the group myself, becoming the first NY Stuckist. The group has since gone international with chapters around the world. Since then, I have participated in numerous group exhibitions with Stuckists in the UK. I was also interviewed as a direct result of my

participation with the group. Since Facebook has come on the scene, I have formed personal relationships and friendships with many Stuckists all over world, including some in Iran, France, New Zealand, and all over the US and the UK. Three Stuckists have painted portraits of members they have gotten to know specifically through Facebook, and I have been lucky enough to have my likeness appear in all three groups. I have received invitations to visit and stay with several members in the UK, which I am planning to do next year, finances permitting. www.artgalny.com

Samira Abbassy

Samira Abbassy is an artist and art administrator in New York. She has used Facebook to make new connections with people and solidify weaker connections. She said that relationships can be fostered through Facebook, and that she has found many opportunities through it. As a general rule, she posts pictures of new art on Facebook when she makes it. Sometimes friends or curators comment. As a result, she was approached by one curator that put her in a university show in Connecticut. Samira feels that it is easier to find people on Facebook and that it allows artists to be exhibited all the time, which opens up many possibilities. www.samiraabbassy.com

Lisa Pressman

Lisa Pressman points out that Facebook makes it possible to network with artists and curators all over the world. She is the

Aaron Fein is forty years old and a father of two children. At first he resisted Facebook, but he eventually managed to connect with friends and others who helped him finish a long-term 9/11 memorial project.

mother of two children and uses email and Facebook to connect with shows and find other sales opportunities. For her, it is all about long-term relationships; she might end up emailing or messaging the same people for years. Sometimes she meets them at parties or online and then asks them directly about working together. Thanks in part to this technique, she is represented by five galleries. Her method is elegant and simple: keep showing people what you do, and ask them if they want to work with you.

Of course, this strategy applies for gaining exposure in print and online as well. Lisa once saw a photographer looking for artists' studios to photograph, so she contacted him and invited him to photograph hers. The photo was a featured image in a *Huffington Post* article. She stressed that her success can be attributed to her pursuing people through social media—a channel that is often less crowded than email in-boxes. www.lisapressman.net

Aaron Fein

Aaron Fein is forty years old and a father of two children. At first he resisted Facebook, but he eventually managed to connect with friends and others who helped him finish a long-term 9/11 memorial project that he was working on. In February 2010, his wife helped him write about his project and post it on Facebook. He found that this allowed him to interact with people and discuss the project as well as his process. An online community formed, which became part of the project. He was not very comfortable self-promoting and asking for money—

he still isn't—but he was able to raise money and aware-ness gradually through Fa-cebook, little by little, by ask-

I raised that money in just ninety days, and we sold over $16,000 worth of non-visible art!

ing for sponsorships, asking people to help with parts of the project, etc. Also through Facebook, Aaron met someone who was driving through forty-eight contiguous states and volun-teering, doing "service" in different places. After he sent him a Facebook message and explained his art project, the volunteer agreed to come by to help. Aaron said that experience alone strongly affected him and his children, and could not have happened before Facebook existed. www.aaronfein.com

Kickstarter.com

The fundraising platform Kickstarter has resulted in the most success stories for artists launching projects and shows in-dependently. With Kickstarter's help, artists can propose anything from a book to a film to an album, and seek fund-ing for their project. My own story is detailed later in this book, but to summarize here, the project I proposed was to make a museum. My wife and I created what we called a Non-Visible Museum and sold imaginary artworks. That's right! The owner would receive a card with the description of the work on it. I raised that money in just ninety days, and we sold over $16,000 worth of non-visible art! I describe this process in great detail in chapter 14, but it goes to show how useful Kickstarter can be for raising money in a short period of time.

Another Kickstarter project that was very successful was called the Regretsy Tarot, which was created by a group of

international artists who got together by email. Each one of them made a few Tarot card designs for a deck to be printed. They sold the decks in advance on Kickstarter so that they could pay to print them. They only needed $4,000 dollars, but they sold out of all the decks and raised over $23,000 before even printing them! The success of that project also derived from its collaborative appeal and greater outreach because more than one artist was involved, bringing in more circles of friends. Research "Regresty" and "Non-Visble Museum" on Kickstarter and you will see both archived there.

Let's Go Already

Now you should be ready to dive in to the world of social media! If you are a total beginner, then turn to the next chapter, where I lead you through the very first steps to setting up a new account (and a new beginning). If you are already a Facebook or Twitter user, then skip to chapter 3, where passwords are discussed in a chapter that will serve as the foundation for everything you do online. Nothing is safe online unless you put security first!

Facebook and Twitter for the Complete Beginner

T his chapter is for both those who are new to Facebook, Twitter, and other social media and those who use Facebook sparingly and reluctantly. More advanced social media users can skip to the next chapter. I write a weekly newsletter, and one time I was writing about managing all of your social media accounts. I received this letter from one of my readers.

Dear Brainard,

Yes, there are artists who have never used Facebook! (More time attaching me to my computer screen.) I thought it's enough to have a website. Please tell those few of us, what should we put on our Facebook page? How does this reach the people I need to

reach? And would it link to my website? And then, how does Twitter get me contacts? Who do I send it to, or does it just go out to the whole world? Does Facebook go out to the whole world? Yeah, I know this is embarrassingly basic. Thanks, Stephanie

I will answer Stephanie's questions here in detail to cover the basics. Even if you decide not to use social media tools at all, the information in this chapter will familiarize you with the language associated with these tools, which we encounter more and more often in movies, on television, and in print. These words have entered our daily slang, sometimes taking on new meanings and even becoming verbs; for example, to "like" a page or "friend" someone are now common expressions. All of this and more will be discussed in this chapter, which deals with the very first steps to using social media and your website to promote your artwork.

Artist Websites and Their Purpose

Artists have been building websites (or having them built for them) for over a decade now. For many, the purpose of their website isn't clear. Is it a showcase? A virtual gallery? Or is it a commercial site through which to sell one's prints or original work? Most often, it ends up being a sort of archive of an artist's work, in which pieces completed by the artist in the past are organized according to year. What we have learned from artists' websites is that they are largely ineffective. This is not to say that they can't help artists in many ways and even help them to sell their work, but the idea of a website that needs to be updated frequently comes with two problems. One is that,

in most cases, it actually doesn't change much or get updated too often, so there is little incentive for anyone to visit it more than once. Two, it is often the case that

If you have a website already there is really only one thing you need to do at the moment, and that is to make a link on the first page of your website to your Facebook and Twitter accounts.

the artist cannot change the website by themselves; they need to pay someone to do it. Those are two big problems, and even if you can update the website without a professional's help, number one is a big problem unless you are updating the site all the time. This does not mean you should give up your website, however; it just means that it needs to be linked to your social media pages.

Website Ranking

You have probably heard about "website ranking," which determines how likely it is for your art website to come up in online search results. Those rankings are determined in part by how often the content changes on your website—that is, how often you put up new images. If you don't make those updates every day, your website will not be ranked very high.

But do not fear; it is still valuable to have a website, and I'll explain why. If you have a website already there is really only one thing you need to do at the moment, and that is to make a link on the first page of your website to your Facebook and Twitter accounts (more on those in a bit). You may decide to change your website at a later date, but for now, let's keep it simple; just leave it as it is but add links to get people to go to your Facebook page and Twitter account. Your webmaster

can easily do that for you once you have set up accounts, or you can try to do it yourself.

How to Figure Things Out on Your Own

Here is some advice on how to use your computer to figure out things that you don't understand. Make believe that your computer is like a '70s sci-fi machine that knows everything. If you are intimidated by the thought of opening a Facebook account, just go to Google.com and type "how to open a Facebook account" into the search bar. Your results will be a combination of pictures, videos, and articles. I tend to choose the videos because they are usually YouTube videos made by users who walk you through the process in a very visual way. Some are better than others, but I find that this is a great way to learn something; it covers the specifics without getting too complicated. If my computer is acting strange and having specific problems, like displaying a specific error message, I might type into the search bar, "My Mac computer keeps saying there is an error. What is a kernel panic?" I often get the answer to my questions very quickly this way.

Opening a Facebook Account

Your next step is to open a Facebook account. You can open a new one if you have one already, but let's just say, for the sake of illustration, that you are opening an account for one person, yourself, for the first time. Go to Facebook.com and you will be asked if you want to sign in or create a new account; in this case, you want to create a new account. You will be asked for your real name, and because Facebook is kind of like a phone book for the twenty-first century, it is good to use

your real name if you want people to be able to find you. You could specify that you would like your name to be unlisted, just like in the old phonebook, or you could make up a last name or create a pen name. This is just an option. To start, I suggest using your real name. This will be the most advantageous for you, because you will be meeting people and in most cases you want them to remember your name, not your made-up name.

Private Information

After you enter your name, they will ask for your birth date. If you are concerned about this, you have a few choices here. You can either lie about your birth date and say you are one hundred years old or something, or you could put in your real

Once your account is activated, the fun begins.

birth date. If you put in your real birth date, you can also check a box that says not to display it on your profile. This way you know that it will never be available to the public. Because Facebook is built on personal information, it helps to share it, but of course it is your choice—and although it's big right now and it does not look like it will pass anytime soon, you can opt out of this system altogether if you like. Having said that, I recommend creating an account and just sharing as much information as you're comfortable with.

The password you will be asked to create should be unique. Make it different from the one on your email address, please! This is a big warning; I have written a whole chapter, the next one, on passwords, but for now, take my word for it that your password for Facebook has to be different, and hard to memorize!

The process of signing up will not take long, and you will be asked to confirm via email verification, which means to send back another email or click a link in order to confirm that your email address is valid. Once your account is activated, the fun begins.

Logging In to Facebook

Go to Facebook.com and bookmark the site in your browser. Click on the sign-in button and enter your email address and your password for the account. (If you have a password program that collects passwords, save this one.) Once you are signed in to Facebook, you'll see a bar on the left side of your screen that shows how much you have left to do to set up your

account. There is usually a single bar graph that shows you how much you have to do to complctc the process. You might be thinking, *Hey, I already signed up!* but you still need to add your photos and more information to flesh out your page. It's a lot like creating a web page. To do this, go to your profile, look for the word "edit," and click on it. If you can't find that word, just let your mouse hover over or near the word "profile" without clicking it, and you will usually see an edit button there.

Editing Your Account

Once you've begun editing, one of the first things you'll be asked to add is a profile photograph, and a timeline photograph at the top. This is fairly easy to do. There is a button after you click on the words, "add your photo" that says "browse." Click on that browse button. Now you are looking through the files on your computer for an image. The picture you choose for your profile picture will be the one that is most seen by people but it will also be displayed at a very small size most of the time. This picture does not have to be a picture of you. It could be of your art, your dog, your town—anything at all—and you can change it as often as you like. There will be more questions to answer before your profile is complete, but you do not have to put up any more photos yet, other than one more for the top of your page which is the biggest image. Seen on your page initially. So use your art here or something beautiful. You will have to crop it into a landscape, horizontal image, but it is the same process as your profile photo.

As you move down the list of things Facebook is asking you to complete, you will see areas where you can fill in your education and interests. I would only fill in the essentials. It is good to

put down your real university if you attended one because Facebook is one of the best ways to keep track of and get in touch with your former classmates. At the same time, it's good to know that you can block people you do not wish to talk to. Privacy and stalkers are taken very seriously on Facebook, and there are many controls to allow you to limit what can be seen of your personal information, and it's easy to change your privacy settings.

Privacy Concerns

I want you to enjoy Facebook and find it easy to use, but the privacy settings are up to you. No matter how secure the billion-dollar network of Facebook may be, hackers can find a way to access your personal information or fool you into signing up for silly Facebook games that could end up being a problem. I am not trying to scare you, but we are all taking a risk by putting our information out there. At the same time, you are an artist, and that is part of your mission, to show and exhibit your art, your writings, and your interesting self, and you can't share all this with the world without incurring some risk.

Adding Friends

Now it's time to begin using Facebook and adding friends. If you have added a photo and some information, go to the bottom of the screen and click the button that says, "save changes." You will also be asked if you want to invite your friends. If you provide Facebook with your email account it can send messages to all of the email addresses associated with your account to ask all contacts if they want to join you on Facebook. You can do this at any time. If you are not sure whether you want to invite all your friends, just wait until later, and click "skip" on that step.

Begin Using Facebook

When you are logged in to Facebook, you will see there are two words in the upper right hand corner of the screen: "Home" and your name. These are the two main portals that you can use to navigate all of Facebook. You will split most of your time between Home and your Profile, which is the button with your name on it. For now, click on the "Home" button. Now look near the top of the page, and there is an empty field that says, "What's on your mind?" Stop. Now click on the "Profile" button which is your name, and locate that similar empty field at the top of the page. It is the same field, and you can use it to enter a short phrase about anything or a link to an interesting video, article, etc. Stop now and write something in that space. It's simple; just do as it says and write whatever is "on your mind." You could write, "I am becoming a Facebook Jedi Master though I am still a Padawan." Or you could say something very casual, like "Just turned on the new air conditioner!" After you type in your first phrase, click the button that says "Post." Hitting your return or enter key is not enough; you have to actually click the post button. Once you've done that you will have sent out your first "status update." You can use your status updates to tell people about an art project you are working on to a dream you had or a show you saw recently that was particularly good.

The News Feed

The next step is to go to the Home button in the top right-hand corner of your Facebook page and click on it. That home button will take you to what is called the news feed. The page you are now looking at, the news feed, is a list of phrases and photos

I will not ask you to spend more than fifteen minutes per day on the Facebook News Feed. You could do even less and still be very effective in sharing the images that you make.

that people have put on Facebook in the last hour or so. If you have added friends and they have been active on Facebook in the past couple of hours, you will see their names and the things they have posted. If not, you will see other people's postings. This page, the "News Feed," is the heart of the Facebook community. I will not ask you to spend more than fifteen minutes per day on this. You could do even less and still be very effective in sharing the images that you make. You can look the News Feed over and scroll down it to see if you find anything interesting, like an opinion you agree with (or one you don't). If you like something you are reading in a short sentence, you can click the little word that says "like" next to it with an image of a thumbs-up. This is what it means to "like" someone or something on Facebook. You should know that you always have the option to "unlike" something in the future if you wish. Take your time to read through this page. This is where everyone is, making it the most interactive page on Facebook. You can make connections just by "liking" other peoples' pictures and pages and making comments. If you get lost somehow, just click the "home" button again at the top right of the Facebook page, and you will be back on the News Feed page.

The Facebook Community and You

Commenting on other Facebooks users' posts is very important at this stage, and I will explain why. The reason you are getting involved in Facebook at all is the same as the reason

for building your website: You want to get your art "out there," you want to connect with as many people who are interested in your art as possible, you want more possibilities. In short, you want new things to happen for you and your art. What makes Facebook special is that it comes with a built-in community, and you can and should take part in that community. In fact, in order to make it work, you *have* to participate. It's really a simple give and take. If you want people to like you and your art, then you have to be interested in other people and other people's art as well. This should come as a relief to anyone who has heard others criticize social networking platforms for making people less social and less generous. In fact, if you are checking out your Facebook home page and looking through the News Feed and liking and commenting, you *are* being social, and people notice. Yes, that's right—they do. You can tell because when you post something, even if it is a status update about your breakfast, when someone comments, *you* notice. When someone either "likes" your comment or writes back, you are notified by email and it also displays on your Facebook page. This is the equivalent of throwing a bottle with a note in it out to sea and seeing if you get a response; if you get a response, you are definitely going to read it.

Posting and Content

You'll notice that some posts get more comments than others. If you are ranting about politics, you will probably get some passionate responses. I have experimented quite a bit with different status updates, and I am always surprised by what gets comments. When I post things about my family, I usually don't get much of a response; when I post about

art, I get more of a response; and when I post about just feeling great, I get the most comments of all. Asking questions sometimes gets responses, but not always. I have been posting a lot about an art project of mine lately, and while I have gotten many responses, it was nothing like the flurry of comments I got last night when I posted this: "I am washing the dishes and wondering how you clean between the tines of a fork. It seems impossible or like too much work. Am I crazy?" Everyone started commenting on how to wash a fork. This may not seem useful, but it is, because people commented on it that I hadn't heard from in a while and a lively and humorous conversation came out of it. Thanks to that status update I reestablished contact with those people, and as a result they may notice when I post about my art in the future.

Comments

One of the more interesting things that can happen through Facebook comments is when an argument or discussion develops between people who are commenting on the same post. However, it has been my experience that status updates that express a sense of well-being get the most responses. Most of my friends are artists, and I would not say that most are inclined to be optimistic. But I think that when someone is feeling good, we want to share in their well-being in the hopes that it will rub off—at least that's my theory. If I write, in my status update, "I love life, I am breathing in deeply today!" I will get at least several responses right away, including comments. I also got a lot of comments when I wrote that I had just gotten a publisher for my book and posted

about him handing me an advance check. Many people congratulated me and made other comments. But again, that was a comment or a status update about celebration, and in general I find that's what the Facebook community is the most receptive to, celebration. Don't you think we all want more triumph in our lives? It can't hurt to make an effort to say things that might make people feel good, because that's what's popular! Is it any wonder? I feel that sharing your art is a form of celebration, it is life affirming and generous.

The Community and Reposting

If you want to be noticed and talked about in the Facebook community, then remember to talk more about the community itself. That means spending approximately ten minutes every day looking at the home page or news feed on your Facebook page. It refreshes constantly, so what you

The ratio of how much time you spend commenting on the news feed to the time you spend talking about yourself or your art should be four to one.

see there will always be the latest news, which on Facebook amounts to what people have posted within the last hour or day. Look over it with genuine interest and thought and check off things you like by clicking the word "like" next to the post. If there is a comment or a statement about something, consider writing back a thought or even a nod of agreement and support. If you don't like to write, consider this good practice. You don't have to write very much, and you will gradually get better and better at making comments and clicking off the things you like. Doing just this for ten minutes a day on weekdays can really make a difference. You will start to see yourself as in dialogue with the community. Your comments don't have to be meaningless or trivial, although they can be. You will find that many people are talking about politics. There are always issues and news stories that get people talking and commenting. You can repost or post a link to a news story that you find interesting.

The Ratio to Observe

The ratio of how much time you spend commenting on the news feed to the time you spend talking about yourself or your art should be four to one. This means that for about every eighty minutes you spend commenting on other people's thoughts and pictures on Facebook, you should spend twenty minutes posting your own content. Or it could be eight seconds and two seconds! I suggest you spend ten minutes a day, every weekday commenting on the news feed, you could

then devote a few minutes to posting your own photos or talking about a show you're having.

This ratio is important because you can use it to determine how you are contributing. This is really the whole concept behind social media, and it is often misunderstood. When you post a photograph of your art on your Facebook wall, which I will explain how to do in just a moment, you will most likely get a comment. When you do, you will make a mental note of who made that comment and you will probably look at their page as well. You might even comment back—not because you have to, but because it is human nature to reciprocate, especially when we're paid a compliment. So take part in the community, comment on other people's art and their status updates, and they will comment on yours in turn. The more sincere and in depth your comments are, the more you will receive the same back.

Posting a Photo of Your Art

To post an image on your wall, click on your name in the upper right-hand corner of your Facebook page. Then you will be looking at your "Wall," where you can post your own comments and photographs. Really, your wall is like a personal web page, and Facebook makes it easy for you to add content, which your friends can then comment on. Probably the best part of Facebook is how easy it is to post photographs to your wall. Obviously, you'll want to add pictures of your artwork, but you can also post photos of your studio, or just a photo you took during a walk. Go ahead and post a few photos of your studio or a picture of a tree or a street scene. Begin by looking at your Facebook wall. You'll notice that towards the

To illustrate the dos and don'ts of friending, let me tell you how I got involved, reluctantly, in Facebook.

top of your page there are four or five words in a row that begin with Share: *Status, Photo, Place,* and *Life Event.* Click on "Photo" and a little box will pop up giving you three choices. You can upload a photo, take a photo, or create an album. For now, let's do the simplest thing and upload a photo. You will be shown a dialogue box that lets you search your computer for a photo. For the time being, make it easy on yourself and choose a photo that is easy to access on your computer. (If you don't know how to put photos on your computer, have someone help you with that part, and then upload a photo.) *Ta da!* That was the hard part. Now you are using Facebook and sharing your art.

You will notice that when you posted your photo, you can also enter in a date and place. Entering the date is a great feature because you can post photos of your art a year ago, or at any time in the past, and it will post lower down on your timeline. If you think of Facebook as one super long page or timeline of your life, the photograph dates make sense of the entire timeline. You can back date images that were created years ago, or an event that happened in the past.

You have learned how to like and comment on comments, how to enter a status update, and how to post images of your art. If you stick to the fifteen minutes a day every weekday, then each session you can spend ten minutes commenting on other people's things and a few minutes uploading a new photo and saying something about it or just posting a status update. This is a powerful beginning, but now is the part where you get to make friends. I discuss how and why to do that below.

Friends: How to Add Them and Why (Dale Carnegie, Pay Attention!)

Having friends on Facebook—as of 2012, you can add up to five thousand of them—is like being on a mailing list. You have the option of inviting everyone in your email address book when you first sign up for a Facebook account. If you haven't done this yet, you can do it now. Click on the small arrow in the upper right-hand corner of your Facebook page, next to the word "Home." Select "Account Settings." Now on the left side of the page you will see the words "Invite Friends;" click on that. Once you do, you can see there are a few options. Either you can enter your email address and password and Facebook will automatically invite everyone from your account, or you can enter in email addresses one at a time. The other way to get Facebook friends is to add them. Once you add a friend, you have to wait for them to accept your request. One way to find friends is to look at the Facebook pages of people like me, as I have many friends who are artists. I already have five thousand friends, which is the maximum, but I have another page as well. Even if you don't "friend" me, you can still look through my friends and begin "friending" them if you like. But please do friend me, because that will subscribe you to my Facebook updates.

To illustrate the dos and don'ts of friending, let me tell you how I got involved, reluctantly, in Facebook.

My Facebook Story

My wife and I are a collaborative art team, and our body of work includes visual art as well as performance and conceptual art. We work with different museum directors

and curators, most of whom are in New York, though many are not. We know that all the relationships we have in the art world are important and, like anyone, we try to be as sensitive as we can and not burn bridges or make enemies, even if we do not share someone's opinion or taste.

The story began one day in 2008, when I got a form email saying that I had been bitten by a zombie and asking me to join Facebook . I usually ignored things like that, but this time it was different because it was from a curator I knew and with whom my wife and I had worked. So, reluctantly, to keep up the playing spirit, I joined Facebook.

Playing Games

At first I found frustrating that I had to answer so many questions, but not taking it very seriously allowed me to start getting very silly with it. For a profile picture, I put an image of Harry Potter that I got from the web. I entered joke interests so that it that sounded like I was ten years old. Ultimately, of course, I joined the Zombies game on Facebook, which was the whole reason I had signed up. I invited all my friends and began exploring Facebook, but I couldn't really figure it out. I kept getting messages alerting me that I had been bitten by more zombies, and I realized that I had to bite back—which meant that I had to invite a few of my friends to become zombies. The more friends I got to be zombies, the more points I earned, and I became stronger and better equipped to win fights. It may sound silly—or perhaps it won't to some of you—but even though I thought it was ridiculous, I became addicted to it. I started to really enjoy competing with the friend and curator who invited me to join

Facebook and play the game. It was just the kind of meaning-less game playing that I had wanted to avoid, but instead I was going on Facebook every day and night to fight zombies and add friends.

How was I finding the friends I needed for my zombie army? I was looking for other artists, curators, and people who liked the arts. I started looking at the Facebook pages of people and organizations in the art world, including critics, well-known artists, and galleries and museums. I would then look through their friends and click on the "add friend" but-ton, thinking that those people might have interests similar to mine. If you look at someone's wall and you like the comments that someone else is making, friend them. That's what I did, and before long I had an entire army of zombies!

Friend Limits

Facebook is designed to make you want to connect with other people and make more friends. However, Facebook discourages random friend adding because they want to generate real conversations rather than meaningless lists of friends for gaming purposes. If you add too many friends in a day, Facebook will send you a warning. If you continue to add friends, Facebook will turn off your account and tell you that you broke the rules. I know because it happened to me. You can either start another account at that point or you can appeal, which is what I did. I searched, "What to do when your Facebook account is shut off" online, and I found an email address to which to write an appeal letter. I simply wrote that letter and my account was restored.

More Friends

The rule-makers at Facebook are really not after individuals who are adding too many friends; they're after bots, which are automated programs that create Facebook accounts and automatically generate friends. Why do bots exist, you ask? Because having a lot of friends actually translates into real value. If you are an artist for example, having many friends is valuable because a lot more people will be seeing your art, and they are potential customers or partners of some kind. If you are a businessperson or corporate employee, you are making friends and mixing business with pleasure a bit, and that could turn into professional advances for you as well as personal benefits. As an artist, you are sharing your work and telling people about what you are doing, just like any person

who has a message that they want to share—and the more friends you have on Facebook, the more the message of your art is shared.

The more friends the better, especially friends who are interested in art, because your work can rcach thc world through them.

In short, the more friends the better, especially friends who are interested in art, because your work can reach the world through them.

Your Schedule

As part of your fifteen minutes a day, you can try adding two or three friends that you have found on the Facebook pages of other friends in the arts. That's it! Take it slow at first so that you don't risk adding too many friends and getting a warning. When you add a friend, you have the option of sending a personal message with your friend request. In my opinion, it's smart to add a short personal message, even if you send the same message to everyone. When someone friends me now on Facebook, the first thing I want to know is if they're a spammer. It's hard to tell, but I usually check to see how many friends we have in common, and if they send me a personal message, that's a good sign, too. I almost always add people who send me personal messages because I know they're real and not just adding friends for game points or something. I suggest that you come up with something short, such as "I am an artist and I would like to keep in touch . . ." Sometimes I'll try mentioning a friend we have in common and say something like "I would like to be your friend. I'm a mutual friend of Sandy Robbins and I would like to keep in touch." That's another good way to introduce

yourself, but you could make it more casual or more formal depending on who you are friending. For example, if you're writing to family it might be more casual, whereas if you're writing to a museum curator or gallery director it might be more formal. In general, I think it's good to err on the side of being too polite. It's not too much to say this in a note for a friend request: "Dear John, I would like to talk about art with you and Kristine, who is a mutual friend. I would also be interested in perhaps interviewing you as well. Best, Brainard." Of course, you do not have to say you want to interview them, but I can tell you, I have been interviewing people for years, and pretty much everyone likes to be interviewed. I could meet almost anyone at all by sending them a legitimate interview request. Everyone loves to talk about themselves, especially famous artists, curators, and celebrities. They are selective in the requests they accept—they have to be—but if you are sincere and have a place to publish the interview, even a blog, you can interview almost anyone.

However, the friend request note we are talking about need not go that far. Most people will accept your friend request. Some people like to keep their Facebook friends true to life, meaning they have to have physically met them before accepting their friend request. You can draw the line wherever you like. You do not have to accept any friend requests, and when you get one you can always use the "not now" button and make a decision later; the person requesting your friendship will only see that his request is pending. Don't worry about hurting this person's feelings if you decide not to add him.

Special Friends

Of course, there are exceptions. Consider for example the special cases of family and exes—that is, past lovers, spouses, and family members. Once you friend someone and she or he accepts your friendship on Facebook, you are connected to her Facebook page and see her daily news and updates. This works for many relationships but not all. The first time I heard about a Facebook relationship issue was with teenagers and their parents. One woman told me that her daughter would not accept her friend request. The daughter had her reasons no doubt; she wanted to talk to her friends in privacy. This became an issue for the mother and daughter, but the mother eventually came to understand, and the daughter did eventually accept her mother as a friend. The mother posted the news on her Facebook page, saying "My daughter finally accepted my friend request today!" That post was funny of course, but it also illustrates how Facebook users make an effort to control who sees their pages and who does not.

Teenagers

I have a relative who is a teenager and attends public school in New York City. He's on Facebook, and of course so are all his friends. He accepted my friend request, so I'm able to see how he uses Facebook and communicates with his classmates. Looking at a page like his gives you a clear sense of what tools on Facebook are used most often. There are video chats with friends, abbreviations for everything you can imagine, and quite a bit of cursing and off-the-cuff comments. Because his

> Ex-spouses and ex-lovers make up the next category of friends and are to be added with caution. You should generally not add an ex-lover or spouse unless you want them to comment about your new relationships.

page feels very informal and he seems to say whatever he wants, there is even more reason for him to screen friends, in case he doesn't want an ex-girlfriend or someone else to see the page.

Ex-Spouses

Ex-spouses and ex-lovers make up the next category of friends and are to be added with caution. You should generally not add an ex-lover or spouse unless you want them to comment about your new relationships. Be careful, because un-friending someone isn't always easy to do, especially if you are just breaking up. Facebook is aware of these kinds of issues; in fact, when you first sign up and give Facebook your basic information, it asks you what your relationship status is. If you check "Married" or "Single" you can always change it to "It's complicated" or something else. In the new world of social networking, relationship status can be mysterious or not, but it is something to be mindful of at the very least.

Enemies

Another issue is sometimes having friends that don't get along. There are a lot of groups that you can join on Facebook, and I ran into some problems, (albeit a very minor one) after joining a group that will explain what I mean. I joined a Facebook elementary school group after I was invit-

ed by a past classmate from elementary school. That's right, it was a page for my very first school! People often make pages about schools so they can get in touch with friends from that time. I recognized a few names and joined. On that page, if I recognized someone, I made a comment on his or her photo. Then I realized that I had several old class photos stored away somewhere. I found one, I scanned a photo of the class picture from fourth grade. On the elementary school Facebook page there is a place where you can post a photo. I posted the photograph of my school picture from fourth grade, which had about thirty students in it, neatly arranged.

Tagging

Once I posted the picture, other former students began commenting on it. What happened next was really fascinating. People began to "tag" the photograph of the group of children. "Tagging" means identifying other people in Facebook photos so that their names are displayed under the image. When you are looking at a photograph of people on Facebook, there is an option right next to the photograph that says "tag this photograph," and if you click on it, you can drag your cursor over the photo and click when it's hovering over someone's face. A form will pop up for you to fill in that person's name. After you tag one person or several people in a picture, you click a button that says "done tagging." What you are left with is a caption underneath the photo with everyone's name in it. If you casually move your cursor over the photo, you will see who's who in the picture. Pretty neat, huh?

What was interesting about the school photograph was that names that I had forgotten other people remembered. Before long, almost everyone had been tagged in the photo. For me, this was a turning point in using social media tools. This was not about sharing my interests or liking someone else's pictures; it was about memories and people from the past that I enjoyed for purely sentimental reasons. Some people hate that aspect of Facebook, but for me, it was welcomed and inspiring.

The story I want to tell about this post on the elementary school group's wall is about enemies and how they can come together on Facebook, often in these types of group pages. You might not want to be friends with someone on Facebook, but you may have to see their posts on a group page that you belong to. In this case, I was watching my old school photograph get tagged and remembering all those names. Below the photograph, people were commenting on the image and their memories. I recognized the names and commented back, enjoying myself. Then I got a private message from someone who was commenting on the photograph. (On a side note, a private message is the same as an email inbox message, and you can send anybody that is your friend a direct message by clicking on the "send a message" button on the top right of anyone's Facebook page. It's just like email, but with less spam, and it's very easy to read. You can read your messages by going to the top left of your Facebook page and clicking on the envelope icon. Then you will see your messages and you can easily respond to them in the space below.) The message was from a friend who told me that she hated someone else from our elementary school class who was commenting on

the photograph. She told me a story about something that happened between the two of them as children that permanently damaged the relationship for her. She said that she wasn't speaking to her anymore but she wanted to tell me because she didn't like being in the same stream of comments as her ex-friend.

Relationships between Facebook Friends

Of course, I understood. Then, I got a private message from the other person involved, the ex-friend, who said she knew that what she did in the past upset the other friend and hoped her old friend will forgive her, going so far as

Just like in the real world, there can be relationships that are tricky to navigate on Facebook.

to ask me to put in a good word for her! You see how complex things can get on Facebook? Luckily, it's fairly easy to deal with this, because there are lots of privacy barriers in place on Facebook. I just responded to both people politely and said that I understood. The point that I am trying to make is that just like in the real world, there can be relationships that are tricky to navigate on Facebook. I have found this to be a very minor issue for me, partly because I am in a stable relationship and have been for several years, and partly because I don't gossip much or talk about people I prefer not to be friends with.

Removing Comments

On your Facebook page profile—also known as your "wall"—people can post comments, pictures, links—pretty much anything. If someone is bothering you by posting unwanted comments on your wall, there are several ways to take care of it. If you are looking at the post on your wall, you can move your cursor over the upper right-hand area of the post and you will see a little "x" appear. Click on that and you'll be given several options. One is to remove the post; another option is to mark it as spam; and a third option is to mark it as abusive. You also have the option of blocking that person permanently. Once you block someone, he won't be able to see your wall or your status updates, and won't be able to comment, post, or send you private messages anymore. Your Facebook account should be set up so that only your friends, who will include other people in the art world

you might want to meet, can view your work.

Facebook and Your Website

> You might announce an upcoming show or event on your website, but this is even easier to do on Facebook.

The next task to tackle is making your website and your Facebook page talk to each other. Now that you understand most of the basics of a Facebook page, you can see that it is very different from your web page in some ways. It is similar in that both your Facebook page and your website display images of your work. On your website you will probably have past and current images of your work, whereas on your Facebook page—especially if you created it only recently—you'll probably have mostly current work. Also, whereas you might announce an upcoming show or event on your website, this is even easier to do on Facebook; all it takes is for you to write a sentence in your status update and click the share button. You can also create an "event" and invite people to it, making Facebook the better venue for promoting your shows.

In a moment I will explain how to connect your Facebook page and website, but first I want to talk about things you might hear concerning the "ranking" of your website on Google. Before Facebook, getting webpages to appear at the top of the list of results for a given search term was a big concern. For a corporation, this could mean getting its website to come up at the top of a search about its product for you. Now things have changed a bit on the web, so it's not just about getting a website to be ranked higher in search results. Though that still helps, having your Facebook page come up first when someone searches your name is just as useful,

especially if someone is trying to contact you. I mention this because there is a lot of talk about website ranking, but it's not as big an issue for an artist, unless many people on Facebook share your name, in which case you want your page to come up in a search first. I'll explain how to marry your Facebook page with your web page so you will get a higher page ranking and be easier to find.

The Webmaster and Widgets

The first thing to think about is who is going to design your website? Unlike Facebook pages, web pages have to be built from scratch, and that usually costs money unless you do it yourself. Let's imagine that you are paying a friend or a web designer to update your website. Here's what you'll do: You will send your web designer (who you trust) your Facebook username and password so she can access your account. Tell her you want a widget on your website's homepage that links to your Facebook page. It is not a difficult thing for a web designer to do, and it should cost very little, but the advantage of doing this is huge.

There Are Many Widgets

Widget boxes come in different shapes and sizes. I recommend telling your web designer you want a rectangle, either tall or wide—whatever fits best. Your homepage is the first page people see when going to your website, so place your Facebook widget somewhere noticeable. Your Facebook widget will look almost like a mini-Facebook page; your name, your profile picture, and your latest update will be there. It can also show you other things, like recent posts, but the basics are probably enough. This will make a fantastic little addition to your web-

site, because it updates itself automatically, and it does it continuously. Now there's no need to pay your website designer to make constant updates or update your website yourself, because the Facebook widget will show

The first step is to make a Facebook page, then send friend requests to your real friends as well as other people in the arts who you want to be in touch with. You will find those people by going to other artists' Facebook pages and looking at their lists of friends.

updates from your Facebook page as soon as you make them. That is how you join your website and your Facebook page.

Some other advantages to adding a Facebook widget are that your website will always have current information about what you are doing and people can add you as a Facebook friend by clicking the widget and going right to your Facebook page to make a friend request. There is also a Twitter widget that you can add to your homepage next to the Facebook widget. (More on Twitter later.)

Summary Thus Far

To recap what we have said thus far, the first step is to make a Facebook page, then send friend requests to your real friends as well as other people in the arts who you want to be in touch with. You will find those people by going to other artists' Facebook pages and looking at their lists of friends. Next, you will familiarize yourself with the different features of Facebook by uploading a few pictures onto your page and looking at other peoples' pages and "liking" things and commenting on them. Lastly, you will sync up your website and Facebook page by having your web designer install a Facebook widget on your website's homepage.

Twitter

Next up on our list of social media platforms is Twitter, which is actually much easier to use than Facebook. Twitter is a platform that simply sends out short messages of 140 characters or less, known as "tweets," to a group of people who choose to "follow" you. To give you an idea of the maximum length for a tweet: "I am painting my studio and I keep stopping to read the articles on the newspapers I use to catch drips. How distracting, how educational!" That one was actually 138 characters, but you can't go over the limit of 140 characters, or the sentence will be cropped. That's pretty much all there is to know about Twitter. You send out messages that may be unimportant, important, or even breaking news. It may seem rather useless for most people, but like Facebook, Twitter gives you access to a huge network, and as with Facebook, it can become intimate in that you can make real contact with people by sending a private message. For the purposes of this chapter, we'll cover the basics.

How to Sign Up for Twitter

To get started, go to Twitter's website at www.Twitter.com. You will see the space for starting a new account; be brave and click the sign-up button.

The process is similar to Facebook at the beginning. You will be asked for basic information. Although I have written a whole chapter on passwords, this warning bears repeating: Do *not* use the same password as your Facebook or email account. Pick something new, please. After you have set up your Twitter account by responding to the verification account set-up email

that will be sent to your email address, you'll be ready to go.

On Twitter, friendship doesn't have to be mutual. In other words, you can "follow" someone without him "following" you, and vice versa.

The first thing you can do is look at your Twitter page. You may notice some similarities to Facebook, but it's actually much simpler than Facebook. As with Facebook, there are four buttons at the top of your page; you have "home," "profile," "messages," and "who to follow." Those are the only buttons you need. You'll also see the space where you write.

Your First Tweet

Now that you have set up your account, click on the "home" button at the top of your Twitter account page. You should see an empty box there with these words above it: "What's happening?" Take a deep breath and fill that little box up with some words. You could say, "I just opened my Twitter account!" Then click the button that says "Tweet." With that, you have just sent your first tweet. For the most part, that's all there is to Twitter. You can send out tweets as often as you like. The next step is the equivalent of adding friends on Facebook. On Twitter, it doesn't have to be mutual. In other words, you can "follow" someone without him "following" you, and vice versa. If people boast about how many friends they have on Facebook, the equivalent on Twitter is boasting about how many people are following you. In order to understand this, we need to try it out.

Following People

Begin by clicking on the next button at the top of your Twitter page, the one that says "Profile." When you click on this

you will see the page with your information on it. Now look at your picture if you have one, the way your name appears to the right of it, and most importantly, the blurb under your name that says a little bit about you. That little blurb is important, because that's what everyone will read first to see what kind of a person you are. You can see how other people write theirs to get help, but if you want to keep it simple, you can just say something like, "I am an artist. I like to play video games, and I like to look at art." You could certainly write something more interesting that says more about you, but this is a good start. The way you do that is to look just below your picture on the profile page and you will see the words "edit your profile." Click on those words and you'll see where to enter your first and last name and where you can enter your website information and a few other things. There are also more account settings on this page, but for now you can just update your information and click "save changes."

Finding People

Next, go to the top of the page and click that profile button again to see the changes you just made. Now for the best part—and the easiest part—which is to follow people who you find interesting. So click the button on the top that says, "Who to follow." After you click on that button you will see a new page, and on the left-hand side of that page you'll see a long list of suggestions for whom to follow. When I did it in the summer of 2011 the first name was Barack Obama. When you follow someone, you are simply enabling your Twitter account to display what that person has tweeted. But let's continue with how to follow someone. You see on your Twitter

page that the button "who to follow" gives you a whole list of potential people to follow. Now all you have to do is look to the right of that person's name and you will see a green button that says "Follow." Click on that button and it will instantly turn into a bigger green button that says "Following." If you want to "unfollow" that person, just click on the button again.

Now you know how to follow people and post tweets. If you are looking for more people to follow, you can look at other people who have Twitter accounts and see who they are following. You can do this by clicking on the name of the person you just followed. You will see her page and in the upper right-hand corner you'll see the words, "followers" and "following." Click on the word "following" to see a list of everyone they are following. Just as with the other list of people to follow, all you need to do is click "follow." It should seem similar to the process of adding friends on Facebook.

If you choose not to go any further with Twitter, that's all you need to know. Since we've been talking about your art website, you can do the same thing with Twitter that you did with Facebook. You can add a Twitter widget to your website's homepage, right next to the Facebook widget, so that when people arrive on your web page they will also see your most recent tweets, or what those you follow are tweeting.

More Advanced Techniques

The next chapter will cover more advanced techniques for Twitter and Facebook, but the wrap-up of this section is as follows. You will set up basic accounts on Facebook and Twitter. On Facebook, you will post pictures of your art and your studio and talk about them. You will also add friends and

> *The homepage of your personal art website should have two widgets on the home page, one for Facebook and one for Twitter.*

comment on other peoples' posts. On Twitter, you will just make comments about your art and will eventually add pictures there as well. You will follow people that are involved in the arts or related to art in some other way. The homepage of your personal art website should have two widgets on the home page, one for Facebook and one for Twitter. Widgets are little boxes that your web designer can add for you. They'll link to your Twitter and Facebook accounts and update automatically to display your most recent tweets and posts.

Remember, it's all about show and tell. Tell your story and listen to other people's stories, and you'll be on your way.

Chapter 3

Passwords and How to Make the Best Ones

In order to use any of these platforms you need to create an account. You'll probably use your real name and you'll entrust the site with your personal information. All of that seems safe, at the moment. Of course, online security is an issue that you should be aware of. As you create passwords for accounts on websites that draw money directly from your bank or credit card, like Paypal and Amazon, there is a reason for concern. Passwords are the targets of hackers, who steal more than a billion dollars from corporations and individuals every year. This is one of the main drawbacks to getting involved in online business of any kind. For me, the advantages have outweighed that drawback. But you need to be aware of how to protect yourself so that you are not vulnerable to attacks. By attacks I mean not

> **Don't** use the same password everywhere.

only attacks to your bank account, but to all of your friends' email accounts as well. I cannot stress the importance of this enough. I am not trying to scare you off though, because it is easy enough to protect yourself well.

Tools to Stop Hackers

Here are a few rules to follow when creating your passwords. One: Don't use the same password everywhere. That is a very common error. All a hacker has to do is to get you to sign up for something like a gift or a prize or some other site and create a password. It's a safe bet that the password you'll create for the website the hacker owns is the same password you use for everything else. That is a very simple scheme, but it illustrates the importance of creating different passwords for different accounts. Also, you should mistrust any sites that ask you to sign in and create a password unless you are fairly sure they are legitimate. Don't panic; I know you already have ten or more similar passwords. Change one at a time, especially your Gmail and Facebook account passwords to something very hard or impossible to remember, and write it down! Change one today.

Your Address Book

I know this doesn't simplify things for you, but if you are going to dive into the world of social networking and online shopping, you have to protect yourself against identity theft and other types of cyber crime. As soon as someone gets hold of the password to your email account, they can send

messages to all of your friends, and they can hang on to that list even if you get your account back. You have

> *Make an extra effort to choose passwords that are strong and difficult to romombor.*

probably experienced this before: You get a message from a friend or relative's email address with a link that sends you to the site of a Canadian pharmacy or similar. That's why you want to prevent having your email hacked, so be sure to use a unique password for your email address and everything else. Make an extra effort to choose passwords that are strong and difficult to remember. That is the only way to protect yourself. Anything less is taking a risk—a big risk.

Multiple Account Mistakes

Think about what happens 90 percent of the time: You have ten, twenty, or many more accounts on the web, and you can't remember different passwords on all of those. So you make the first big mistake by choosing something memorable like "123456789," or the name of your pet, or "qwerty." But just as there are top keywords and phrases that people search for online, there are lists of top passwords that are used. That means that anyone who knows how to program a computer to sign in to hundreds of accounts automatically can use trial and error successfully by experimenting with all the passwords. So if you have one of the top one hundred most popular passwords, or even the top one thousand, you are in trouble. The risk is real, and I think we have an obligation to also protect our friends and family members whose emails will be spammed and worse if our account security is breached.

The point of Xmarks is that you will have all your impossible-to-remember passwords stored in one secure location, which you can access using only one password.

Impossible-to-Remember Passwords

The answer, again, is creating passwords that are impossible to remember, full of upper and lowercase letters as well as numbers and punctuation—for example 7jfYf@fj#Xv0o2. That's a good password, and very hard to remember. Sometimes people will try to create strong passwords by using the "at" symbol or a 3 to replace a letter, as in "s@yg00dby3" and "s0cc3rRul3s," both of which are not good passwords because they are relatively common, believe it or not.

How to Remember Passwords

The next question to resolve is how are you going to remember all your passwords if they are meant to be impossible to remember and they're all different? I use a program that remembers all my passwords on multiple computers called Xmarks. There are other programs, but of course you have to trust them. The best way to evaluate the trustworthiness of password storage programs is to look up reviews and see which ones get the best ratings and comments. For example, LastPass, KeePass, and 1Password are all good programs, and you know that you can trust them, because they have gotten plenty of reviews. The point is that you will have all of your impossible-to-remember passwords stored in one secure location, which you can access using only one password. That means that you only have to remember one—ever. It also means that the password you pick for your password

storage account has to be fantastic. No kids' names, birthdays, pets, or anything else; pick something really good and practice remembering it, or write it down in a secure place.

If you look at a service like 1Password, which has a yearly fee (and is totally worth it), there is more there to help you. Even after you have stored all your passwords securely, you may still find that they are not very strong. Every time you enter a password, 1Password asks you if you want to save it, then asks you if you want to generate a better one. It can automatically generate a new, stronger password, and it will remember it. That's very useful, because you can change all of your passwords to random combinations of letters, numbers, and punctuation, like *?tHc#2@knYbsL$jk9x. Passwords like that mean increased security, and with the aid of programs like 1Password, you can have them memorized across different computers and devices. That should help you sleep well at night.

Write It Down If Necessary

The other, old-school solution to remembering passwords is to write them all down somewhere. Because passwords tend to change and be added to over time, it is easiest to write them down in a word processing document on your computer. I recommend either keeping that document in a safe place or uploading it to a private site that can store it for easy retrieval. One free service, which comes with a Gmail account, is Google Docs. This allows you to post documents privately on the web without sharing them. Also, Google Chrome is a great browser and is now incorporating a free system that remembers all your passwords for you. If you use that browser, it is something

> *I could write more about passwords; in this age of online shopping and communicating, passwords are the keys to everything we have — and in a hacker's hands, those keys can be used to steal your money, hassle your friends and relatives, and ruin your day in more ways than you might imagine.*

to consider. If you lose your computer, and can sign into your Gmail account, open Google Chrome, and everything will be back, bookmarks, passwords, everything. Again, that first Gmail password better be a very tough one to remember!

Final Warning

I could write more about passwords; in this age of online shopping and communicating, passwords are the keys to everything we have—and in a hacker's hands, those keys can be used to steal your money, hassle your friends and relatives, and ruin your day in more ways than you might imagine. So take a precautionary step and save yourself some heartache by making your passwords stronger, and making them all different, especially the passwords to your email accounts. Then decide how you will manage passwords in the future. Use a service like Xmarks or 1Password, or save them using a Google Docs or by writing them down on paper or typing them into a word processing document. Just choose a method that you can stick with in the years ahead.

Last Note on Phone Ads That Silently Steal

Another type of cyber crime comes in the form of smart phone adware that adds a charge to your monthly bill without your knowledge. That means, just for clicking on an ad, not buying anything, you could have a recurring charge on your bill.

To avoid this, you should either avoid clicking on ads altogether when using your smart phone or call your cell phone carrier now and tell them that you want all ad-based purchases blocked on your phone. That means you could still buy from Amazon and eBay but you wouldn't be able to accidentally add a $9.99 recurring charge to your cell phone bill that you didn't want!

Chapter 4

Using Social Media Platforms for Sharing Art

Now Internet-based markets and social networking force us into a dialogue with them, no matter what our stance on this new plugged-in culture is. This chapter will provide an overview of the new social platforms that are changing the world and their importance and relevance to the arts. I will go over some of the basics from the introduction to Facebook in Twitter in chapter 2, but the coverage here is meant for users who are already familiar with these platforms and are ready to move on to more advanced techniques.

Lady Gaga and Obama

What do Lady Gaga and President Obama have in common? They both use social media in a masterful way. In 2011, Lady Gaga was the number-one celebrity, ousting Oprah Winfrey

> *Part of what I do as an artist is talk to people who can help me realize projects. They are often wealthy people who are involved in some kind of business, like private bankers, investors, and developers.*

from the top spot, in much the same way that Obama defeated Hillary Clinton by outspending her in campaign advertising. When Barack Obama was running for president he lacked support from the top democrats, whereas Hillary Clinton had those connections because of her time in the White House. That alone was daunting for an underdog like Obama, but he chose a highly effective campaign tactic focused on social media and getting small donations of $50 dollars or less in great quantities. Of course it worked, financially and practically, because he had much more to spend on his campaign as a result. Lady Gaga is in that position because of her talent but also because of her use of social networking. She has attracted millions of fans through her Facebook page and Twitter, and she posts regularly to feed the interest of her growing fan base.

Social media platforms, both established and emerging, are not going to disappear anytime soon. This is your primer on making them work for you, so that you can harness the power that Lady Gaga and President Obama are using to bolster their tremendous success without spending money. As an artist, you are a creator, an inventor, and an innovator. You have that in common with some of the greatest business minds in the world today.

Businesspeople and You: What You Have in Common

Part of what I do as an artist is talk to people who can help me realize projects. They are often wealthy people who are

involved in some kind of business, like private bankers, investors, and developers. I always thought of those kinds of businesspeople as the polar opposite of creative people like myself; in fact, I not only thought that they were *not* creative, but worse, that they only thought about money and were generally unsympathetic to artistic ideas. I had some evidence to prove that point, but that was because I was talking to people who weren't at the highest level of the business world, which is where things really get creative.

A Business Lunch That Didn't Work

To give an example of what I'm talking about, when I first had a major show at the Whitney Museum, I asked a friend who was a printer and had earned enough to have a huge house with a pool and various luxuries to have lunch with me. I wanted him to print a small catalog for me for free; in other words, I wanted his printing company to sponsor it. We met at a restaurant, and I explained that I was getting this major show in the Whitney Biennial and that I wanted him to produce the catalog. I told him I would be giving performances at the museum with my wife and that we would be giving out foot washings, hugs, and bandages. I explained this was a major show, like the Oscars for art or something, and that it would get a lot of press. He kept trying to fit my art into his world. He would say things like, "Oh, so the performance is getting you publicity so you can sell your art?" I explained that the performance was the art, and that there was nothing to sell. He didn't understand that, and he told me that he couldn't help with printing because he didn't have that much

money. I was disappointed and chalked it up to the "fact" that businesspeople don't understand the arts and creativity.

A Business Lunch That Did Work

Then I met another businessperson, a private banker who worked with a variety of companies. He helped the companies he worked for to restructure their businesses and invest properly in order to increase their earnings. When I sat down with him in his office (a few years after sitting down with my printer friend), I found that he was fascinated by the art I was doing with my wife. Even though there was nothing to sell, he felt it could be "monetized" somehow. He was enthusiastic and talked about "repurposing the performance." What did those things mean, I wondered, and why was he so enthusiastic? He was enthusiastic because it was a new idea he hadn't heard of, and it was an exciting challenge for him, creatively, to figure out how to make it a success. When he said "monetize" he meant the process of turning a free performance into money. I had never thought that way.

Monetizing Your Idea

After brainstorming together, we came up with some examples of how it could be turned into money: writing a popular book about it, making it part of a fundraising activity, or doing it as a publicity event for a business or organization. We could also try making stickers, posters, and other related products, which could be sold, and documentation that could also be sold as visual art. The other term he mentioned was "repurposing," which means taking one product, let's say bars of soap, and finding

another purpose for it. In the soap example, there was a fa mous marketing strategy in which a soap company sponsored soap-carving contests

You may be prolific, but if people can't see and enjoy your art, then what is it for? These new platforms are simply a way to exhibit your work on the web.

in schools; thus, the soap was repurposed as a sculptural medium, and sales of the soap increased, as did the visibility of the brand. That is how businesspeople think when they are really good at what they do. These kinds of people should be enthusiastic and excited about your work, because art, and the selling of it, is new to most of them.

This chapter deals with new technologies that can be of use to artists. Creative businesspeople are the inventors of these tools, and they are a lot like you. We will talk more about how to approach them in later chapters, but my story serves to remind you that they can be on your side. They might even surprise you with their openness to your ideas. Creative ideas from creative people are always in demand, and the best entrepreneurs know that artists are at the center of creative ideas.

New Platforms

Facebook, Google+, Twitter, Flickr, YouTube, Instagram, foursquare, WordPress, phone apps, iPad apps, Google AdWords, Facebook ads, and many other new technologies can't be avoided because they're part of a new language that everyone is using. They are ways of reaching out to the world to share your ideas and images. I wouldn't say that it's about "promoting" your work; I would say, again, that it's more like show and tell, just the way you might have done it when you were little. As an artist, either you show the world your work, or it doesn't exist.

Show and Tell

You may be prolific, but if people can't see and enjoy your art, then what is it for? These new platforms are simply a way to exhibit your work on the web. Each platform has its own nuances and tools that make it valuable in its own way. Rather than getting overwhelmed by it all, there are new programs that combine it all for you, so you don't need to spend more time using social media than you want or need to. We will now discuss how you can integrate these platforms and come up with a general plan for how to begin.

Twitter

This is the networking platform that almost everyone has heard of. It has been credited with aiding revolutions like the ones in Egypt, Libya, and throughout the Middle East. It has also helped to draw in crowds at openings and it is now quoted regularly in papers of record, like the *New York Times*. Using Twitter means sending and receiving short messages of no more than 140 characters, or "tweets." Most tweets are either meaningless babble or conversations. For example: "I am eating breakfast in my studio and some oatmeal fell on a painting and I think I like the way it looks, I might call it My Breakfast Art." That is exactly 140 characters—the maximum allowed—and of course most people write much less.

Twitter Conversations

A Twitter conversation might begin this way: "Art critics are often frustrated artists grinding their axes on new artists

seeking approval from them. Do you agree?" That's a bit under 140 characters, but it's a conversation starter that will get other people going, meaning they will tweet back a response. Or someone might forward your tweet, or "retweet" as it is called, sending your question out there for a response.

Twitter as a Powerful Tool for Social and Political Change

Initially, tweets were mocked by journalists as meaningless clutter. But after the disputed presidential elections in Iran in June of 2009, Twitter enabled protesters to mount huge demonstrations and coordinate their efforts. It was such a valuable tool for the protests that the U.S. State Department called the founders of Twitter and asked them not to do their scheduled upgrade—which would make Twitter unavailable for several hours—so that Iranians could continue organizing protests around the disputed election. When it was suggested that the U.S. was meddling in Iran's affairs, State Department spokesman Ian Kelly said, "This is about giving their voices a chance to be heard. One of the ways that their voices are heard are through new media." Since then, Twitter has been seen as a powerful new tool for getting messages out to the world and even changing the world as a result. Now news agencies and just about every celebrity has a Twitter account.

Serious Literature

In the world of literature, Twitter has also given rise to new forms of writing that are now considered legitimate, like the Twitter haiku, or "twaiku." Some major writers, like John Wray, have used Twitter to create serious literature.

"For two years, John Wray, the author of the well-regarded novel, Lowboy, has been spinning out a Twitter story based on a character named Citizen that he cut from his novel . . ."

For two years, John Wray, the author of the well-regarded novel *Lowboy,* has been spinning out a Twitter story based on a character named Citizen that he cut from the novel, a contemporary version of the serialization that Dickens and other fiction writers once did.

"I don't view the constraints of the format as in any way necessarily precluding literary quality," he said. "It's just a different form. And it's still early days, so people are still really trying to figure out how to communicate with it, beyond just reporting that their Cheerios are soggy." (Mr. Wray's breakfast-food posts are, at the very least, far funnier than the usual kind: "Citizen opened the book. Inside, he found the purpose of existence expressed logarithmically. From what he could tell, it involved toast.")

—*The New York Times*

So Twitter is now recognized as a tool for creating art and literature, and is thought of as part of that world. However, whether writers and artists play with it or try to rise above it, there is the daily-nonsense aspect of Twitter. This usually consists of Twitter users' domestic minutiae (or worse), which is the opposite of good literature. Since both types of tweeting—the artful and the mundane—can draw huge numbers of followers, it's important to consider both to be valid.

Having said that, it falls to you to decide at some point how you will use Twitter. You can start by experimenting. Send out anything at all, and then look at what other people are sending out. As you're looking through other people's tweets, you might find some that you like. You have the option of resending these as your own; that is, as mentioned above, you can retweet someone else's tweet. Once you've grasped that, you are well on your way to becoming conversant. It may seem difficult, but it is really a very simple system to use for passing tiny bits of information around.

Facebook

This is the platform almost everyone has heard of, and it has ushered in a whole new age and changed the way we manage information about our friends and relatives. For artists, it has created a new way to share images and information. Facebook also turned a college student into a billionaire CEO, who wears jeans and a casual shirt in place of a suit. The meteoric rise of Facebook seems likely not to be short-lived, as we are all contributing to it by providing Facebook not only with our own personal information but with our friends' information, too. Facebook is constantly evolving, updating itself every day in an effort to balance an uncluttered user experience with advertising revenue needs and privacy concerns.

Facebook: Setting Up Your Account

After signing up for Facebook with a secure password you can enter some information about yourself, which, for the time being, I would keep to a minimum: just your name and your college, or as little as is necessary for you to move forward. Once

As you look at a friend's page, you can look through all of their friends, and chances are you share a friend or two. Those are the people you can start adding right away.

you are set up on Facebook, you will notice that you have no friends. When you're first starting out on Facebook, the main goal is to add friends. You can do this automatically by letting Facebook use your address book to send invites to all of your friends, or you search for and add people you know on Facebook one by one. As you look at a friend's page, you can look through all of their friends, and chances are you share a friend or two. Those are the people you can start adding right away. Those friends-of-friends are the new friends you are making. Once you have added them, they have to accept you as their friend and then that's it. The next step is to write something at the top of your page every time you sit down and look at Facebook. This is the "status" and it shows up as an empty text field. Make it easy on yourself and start by saying something inconsequential, like, "I just ate lunch and am going for a walk." Write something new once a day or every time you look at Facebook. You will notice that people will comment on what you have said and you can reply to those comments, starting a conversation.

Now That You Are Using Facebook

Just like in the art world itself, on Facebook you need to make friends with interesting people who are involved in the arts and are a part of the community you belong to or want to belong to. The easiest way to find the right kind of friends is to look at art publications or even well-known personalities in the art world. The Facebook page of Jerry Saltz, a New York art critic, has the maximum or about five thousand friends

on it, and among them are tons of New York City art world personalities, from collectors to curators, museum directors, writers, and artists. In fact, the Saltz page in particular is very popular, because he manages his page with a certain savvy, and it shows. He has a talent for posting questions and making statements that generate comments in return, sometimes hundreds of them. Those comments are the art world talking to itself. All of the commenters are involved in the world of art, especially the New York world of art. Reading their conversations will not only provide you with insights into that world, it will help you to familiarize yourself all its key players.

Real-Life Connection through Facebook

Facebook is incredible in its ability to make real-life connections and meetings with curators and collectors possible for

you. As you build your network of friends on this platform, you can also send messages to them easily. In fact, you can send a message to almost anyone on Facebook without even being their friend. I discovered this as I was looking through the friends of a curator whose page I found by searching for the word "curator." As I was looking at different people who were friends with the curator, I saw that some were art collectors. I looked at what the collectors were saying on their walls and commented on it or "liked" it. Then I would send them a direct message, even if I wasn't their friend, by using the "send message" option.

Facebook Messages

One of the nice things about sending messages within Facebook is that Facebook inboxes are largely free of junk mail, so people actually read their messages. Once, I decided to message a collector who lived in New York City, and I asked her if she would have lunch or coffee with me so that I could introduce myself. Remarkably, she wrote back right away and gave me her assistant's cell phone number. I made a time and met her, and it was the beginning of a lasting relationship. I messaged a museum director the same way, and I went out for coffee with him, just to get to know more about him and see if there was something we could do for each other. For all the criticism that social networking gets for being isolating and not "real" enough, I say that if you want it to, you can use it to set up meetings with people in the flesh who can help you and support you or just become real, lasting friends.

List of Targets

The next step for you to take at this level is to begin making a list of people you want to meet. If you don't know

> If you don't know who you want to meet, you can begin by searching for art in your geographical area, or you could look at the Facebook page of a local museum and see who their friends are.

who you want to meet, you can begin by searching for art in your geographical area, or you could look at the Facebook page of a local museum and see who their friends are. Some of those people will be collectors you could meet with. The key to finding a market for your art lies in making relationships with people who can help you. You will meet some people who are interesting and some who are not, which means that you will have awkward meetings and enjoyable ones, too.

Take These Steps

Make a plan to contact four new people every week through Facebook. That means not just sending one note to a bunch of people, but rather sending an individual Facebook message to someone you have found who collects or curates art or owns a gallery. This should be someone who is near you or near a city or neighborhood you could easily get to. The reason you give for wanting to meet can be simple: You are trying to meet more people and want to talk about art, that's all. Make a list of at least ten people, and after committing to writing a certain number of letters per week, make it your job to pursue and make new friends in the flesh through Facebook. If you do this, you will be taking advantage of one

of the greatest benefits of the platform, though certainly not the only one.

Commenting and Communicating with Institutions

You should also look at galleries and museums you enjoy and "like" them on Facebook. That will make them show up in your news feed, and then you should occasionally comment on something or "like" one of their shows. This will put you on their radar, and they will have a tendency to click on your page and see who you are and return the favor. Put up images regularly on your Facebook page and tell your friends about your art, also ask questions. This will stimulate conversation and spread the word about your art.

A Word of Warning about Facebook Games

As you may already know, there are games you can play on Facebook which tend to involve inviting your friends to play with you, from Scrabble, which I love, to games like Zombies, where you "bite" friends to turn them into zombies, to games where you make a farm or build a zoo. When friends invite you to play one of these games, it is tempting. I first learned about Facebook when a curator invited me to create a Facebook account, and the next thing I knew he was biting me and asking me to be part of the Zombies game. I couldn't believe it—it seemed so childish—but I did it, on the basis that he was (and is) a very important person for me to know. I ended up getting addicted to the game and started biting all my friends. That is how these games are designed; they're made to be addictive so that you'll invite your friends to play them.

Game Problems

Beware, and try not to participate in Facebook games unless you are designing one!

But here comes the problem. These games can be designed by any independent software developer who wants to make them. Most designers aspire to create a game that will be used by millions so that they can profit from it somehow. Other designers have darker ambitions, like getting into your friends' accounts. Whenever you decide to accept an invitation to join a game, a dialogue box will open that tells you what information the game has access to, and that information will usually be a list of your friends. That means by clicking the "allow" button, you are giving it permission to use all that information. I strongly suggest you refrain from playing any of these games. It is because of them, in part, that Facebook accounts are now getting spammed, like those annoying posts you might see from people who are actually your friends, saying things like, "I got a free iPad, I can't believe it! Click here to get yours." When you click the link you are shown sites that mimic Apple's real site and then they ask you for your zip code, email, and whatever other information they can get from you. There are tons of these types of scams, and their common goal is to get your email address so they can send you spam directly. Beware, and try not to participate in these games unless you are designing one!

Real-Time Chatting/Messaging

Recently, I was using Facebook and making use of the chatting or instant messaging option. In essence, that means privately chatting in real time on Facebook. I had been emailing a

> *Once you have become friends with someone on Facebook, you can open the chat window to see if he or she or any of your friends are online at the moment. If they are online you can open up a chat with them by just saying hello or commenting on something that they have done recently.*

curator and I had even had a meeting with him. Although the meeting was good and he wanted to work together, I could not get a reply from him when I sent a follow-up email. He had asked me to send him emails but was probably too busy to answer them. I wanted to make sure I would be working with him as planned, and then one day I was on Facebook and I saw that he was online and available to chat." So I sent him a message, something like, "Hello, I wanted to ask you . . ." Just like that, in response to an unfinished sentence, he wrote back right away: "What can I do?" So through quick chatting in real time, we sealed the dates for an exhibit. Facebook chatting can be very useful this way.

Immediate Answers

Facebook chat is really a powerful little tool because it's even more intimate than writing messages or emails. When you engage someone in a real-time conversation, it is like having them on the phone, because you can go back and forth very quickly. Once you have become friends with someone on Facebook, you can open the chat window to see if he or she or any of your friends are online at the moment. If they are online you can open up a chat with them by just saying hello or commenting on something that they have done recently. Can this be obnoxious? Yes, but so can email and anything else if you use it in an impolite or intrusive way. If your messages

and chats are kind and sincere, you should be able to get kind, sincere responses from the people you are trying to reach. In the case I just mentioned, chatting helped me to seal a deal, which was very satisfying.

Writing to a Curator

But here is another story about someone I was pursuing through Facebook while writing this book. I added a curator as a friend and sent him a message asking if I could interview him for my radio show. He wrote back and said OK, but he was traveling, so he told me I could contact him the following week. That was after we had exchanged about three Facebook messages.

When I followed up with him the following week to set a time for me to interview him by phone, he didn't answer me. I wrote to him on and off for another two months and I never got a reply. I couldn't catch him on live chat either. After I had written many unanswered emails he eventually replied and said he would be happy to talk and that we should pick a time. He apologized for being busy. I did the interview, it went well, and I now consider him a friend.

I wanted to include this example because this is what happens in the best of circumstances. I knew this guy wanted to be interviewed on Yale Radio, which hosts my radio program on the arts, but the fact is that most people will not return email and calls unless you are persistent. It is a fact that seems counter to reason, but I have found it to be true on many occasions. I have interviewed many businesspeople who have said the same thing: You must call and write to people over and over again. So for the people that do not have an interest in knowing you (like the guy I was interviewing), you have to work harder still.

How to Follow Up

I learned about professionals' approaches to this kind of active networking by talking to businessmen and women who try to make new contacts all the time, and also from a friend who had recently quit her job. My friend, who is a fundraiser with a successful history, felt she was being harassed at her job and went to Human Resources. The Human Resources person asked her not to press charges and instead to take their comprehensive coaching and placement package for as long as she wanted until she found the perfect job. It was a generous offer, because it meant she would be given the personal coaching she needed to land the perfect job, for as long as it took.

 I read over all the materials she had been given and there was a section on following up that nicely summarized what I had heard before from many different people. It mentioned

that when trying to get an interview or meet someone, the most common complaint was that people don't call

Never say that you will just wait for their call; always say you will follow up.

back or return emails. Their solution to this problem was straightforward: Never say that you will just wait for their call; always say you will follow up. That means at the end of every letter you send and at the end of every voicemail you leave after you have sent in a résumé or an application or a set of images, you must say something like, "If I don't hear from you, I will call (and/or email) in two days." Then you contact them in two days. It could be the very same email you first sent, with a note added to the top saying you are "following up on the email below." Then you can end it by saying you will follow up with a phone call. Go back and forth this way until you get a response. You could change the subject of the email to "Following Up." This is really a polite and professional way to contact someone without being a stalker. For most people, this kind of persistence will make you seem very passionate and determined. I send letters and do follow-ups twice weekly. That means you can call or email on a Monday, and then again on a Wednesday or Thursday, and do the same the following week. If it really goes on for months you can sometimes take a week off—but not more—until you get a response.

Professional and Polite

Trying to establish connections with people professionally and politely will get you very far, because most people stop pursuing a connection as soon as a call or email isn't returned.

At the very least, you deserve a response. That's my feeling when I am trying to connect with someone. Sometimes I even continue to follow up on principal, because I believe that everyone deserves a response when writing and asking a question politely.

Applications for Phones and Tablets

Passwords are important, but there are other ways hackers can get into your computer, your mailing lists, and other information. Since the invention of the iPhone and the Android system and phone, there has been a proliferation of applications, or "apps" as they are known. You can download apps for reading books, for playing games, for finding local restaurants, and much, much more.

Apps are also available for Android system phones—which were developed by Google—but with one critical difference. On the iPhone, which is produced by Apple, the apps that are available are very tightly controlled by the company. That means that when someone is trying to create an app to sell in Apple's online store, iTunes, they have to propose it to Apple first. If Apple likes it, then they will make it available for download on iTunes, but if they don't like it, they won't. This is because Apple wants iTunes to carry only squeaky-clean apps with nothing unsuitable for children, which means no nudity or adult references of any kind (although apps that make farting noises are OK). For Android phones, the store allows apps to be uploaded much easier and there are fewer restrictions. This is because Android developers wanted their apps to be even more popular than Apple's, but problems are arising in both companies, so it's important to remain updated and informed.

Phone Apps Have Access to Your Information

Some apps are designed to hack your phone, so read carefully.

Before you download an app, you will have a chance to read a description of it and, most importantly, a list of what it has access to on your phone. In order for an app to work, it has to be able to access some of your phone's data and controls. I just downloaded a timer app, which is like a kitchen egg timer, and I use it to time my meditation sessions, which are twenty minutes long. When I was about to download it, I was told what it would need access to: it was just going to change my phone controls to stop my phone from going to sleep. Apps that manipulate photos will let you know that the app will need access to your phone camera, whereas apps that help with driving directions will need access to the global positioning system or GPS in your phone. That's all OK, but some apps are designed to hack your phone, so read carefully.

The Fine Print

For example, there are apps that change your screen image or "wallpaper" to holiday themes. These simple, free apps can be the worst. One such app will tell you that it needs permission to access your phonebook. You might not think twice about it, but why your phone book? You have to evaluate the situation every time. In this scenario, there is no reason why an app that sends images needs access to your phone book unless it were designed to steal all your mailing addresses and info. It is very easy to download apps without thinking, but this goes to show why it's so important to read the fine print. If you

download an app, just read a little bit about the permissions the app requires. Any app that asks for access to your phone book is suspicious, so you should read reviews of it before downloading. This is less of an issue for the iPhone because the apps are screened carefully, but it can happen from time to time and is still a concern. Now that most people have their smartphones synched with their computers so that their calendars and email addresses are stored on their phones, an app can access all kinds of information and send your friends junk mail from your email address. This is not to scare you but rather to make you conscious of some of the dangers of downloading apps.

Make Your Own App

Now that I have explained how an app can be a dangerous tool for hackers, I will tell you how they can be useful to you as an artist, both as tools for promoting your work and as a means for creating an artwork in itself. With tablet computers becoming more popular and smartphone use on the rise, we are going to see more and more apps in the future. As the industry grows, greater security measures will be taken to reduce the number of hacking apps. However, just as the battle to stop junk email and spam is not over, this will probably take a while. So in the meantime, in the same way that we continue to use email, we can continue to use apps—and create them as well.

First Steps to Take to Create a Game or App for Facebook

Let's begin with how to make an app on Facebook. Unlike iPhone apps and other smartphone apps, Facebook apps are

designed to be played with on Facebook itself. You can get very creative with them, but Facebook makes it easy

I created two quiz apps on Facebook. One was called "Are you an artist destined for greatness or a minor one?"

by offering templates that you can modify. For example, there's a survey app or quiz that you often see on Facebook, with titles such as "What I have in common with Justin Bieber" or "What kind of animal are you?" The point of these is to get you to fill out your answers to a series of questions, and based on your answers, you are given a final grade or category of some kind. These may seem childish, silly, or worse, but people love to fill them out, and this is an easy way to begin to understand how you can use them.

Make a Quiz

You can make a quiz about anything at all. It can be intelligent, funny, and even educational. To give some examples, I created two quiz apps on Facebook. One was called "Are you an artist destined for greatness or a minor one?" In it, I set up about eight questions to answer. I had fun with it and created questions like "Why do you make art?" The three possible answers were: 1. I can't think of anything else to do; 2. I want to make money; and 3. For art's sake. Other questions included "Do you think money and art mix well?" Possible answers to that question were: 1. Sometimes, but not usually; 2. They go together like soul mates; and 3. I hate money because it seems to hate me. Of course, I was trying to have fun with my answers and make it entertaining. I also got to decide what the final result would be depending on how the questions were answered. One of the final

results was this: "Wow, wow, wow! You are a hottie, and it will not be long before you are plucked from obscurity. You have talent, charm, and make art that rocks the inner worlds of your audience. Soon you will be the spokesperson for your generation. Be proud, and lead the masses to cultural literacy!"

Go Viral

That quiz is fun, so it tends to get passed around, and as a result my name is seen in more places, because not only am I listed as the creator, I put my name into some of the questions. To get the attention of curators I made a quiz called, "Are you a cutting-edge fine art curator?" And this is the description: "So you're a curator, but are you cutting edge? Will you be chosen to curate the next Whitney Biennial or perhaps the Venice Biennial? Take this quiz and find out where you stand in the quirky art world that will determine your fate." The quiz-taker answers more art world questions, and when they've finished, the app tells them what I think. I posted this quiz on the Facebook walls of curators and as they filled it out, they passed it on to other curators. One of the questions I asked was, "Who do you think are cutting-edge artists?" Among the answer choices, I included myself and my wife as one option and put us next to Picasso, John Currin, and a few friends. I was having fun with this one, but you can see how it also gets my name out there to curators. Not only that, quizzes likes these tend to get passed around, and because the result of the quiz is published on your Facebook wall, you will have it working for you while you do nothing. In other words, at no cost to you, your name could

be passed around as part of a quiz while you get the benefit of that promotion.

An App as a Work of Art

Another approach to making an app or a game on Facebook is to make it a work of art in itself that is worth passing around. The app I made with this in mind is called "Box that opens when you close your eyes," and it is a series of images and phrases that you can share with friends. The way the game is set up, you can put in perhaps twenty or more items, and then when people share one, they get a message that says that if they share it ten times, they will unlock a new gift, meaning that they will unlock another one of the picture and word combinations I made up. Here are three examples of gifts that I made which are intended to be charming enough

> In the game I created called "Box that opens when you close your eyes," the gifts you unlock are new pictures and words.

to share: a self-eating cake (accompanied by a picture of a cake); a soup that heals all wounds (with a picture of a soup bowl); and a Qwerty Party (with a picture of a keyboard). All of these are a little more artsy than the quiz questions, but they are also more likely to be passed around if people are using them to send messages to friends. I made that one a year ago, and it has been used fifty-seven thousand times so far! Is it art? Yes. Does it help me? I think so, because friends enjoy it and pass it along and they are reminded that I am an artist who works with abstract and poetic concepts. You could say I am "branding" the work that I make under the name Praxis, which is the name under which my wife and I collaborate as artists.

Template-Based Apps and Games

Template-based apps and games are all very easy to make. You just fill out templates, add words and pictures, and then share the results with friends. You can post them on their walls, and when they use them by sending "gifts" to their friends, they unlock new parts of the game you made to share. For example, in the game I created called "Box that opens when you close your eyes," the gifts you unlock are new pictures and words. That is how I chose to design that game app, but you could use images of your own art or anything else related to it.

This is the easiest possible way to create apps and games, because they are template-based, but if you are feeling more

adventurous, you can create an app for the iPhone or for An-
droid phones. That is a bit more difficult, but it is possible.

IPhone Apps and Creativity

To make an app for the iPhone, you would need help, unless
you are very familiar with designing software or willing to
learn. Apple is trying to make it easier for people to create
apps by themselves, but as of this writing, it is still too com-
plicated for most. But hey, you might pay printers or fabrica-
tors to help you with your artwork, so you could consider this
another art supply expense. If you're considering making an
app for the iPhone or for Android phones, begin by looking
at the apps that are out there and deciding if you would make
something similar or different. You might be wondering what
could you possibly make. How about an app for the iPhone
or iPad that allows you to paint by numbers using your art?
Or maybe a puzzle where the final picture is an artwork of
yours? Or perhaps even backgrounds—otherwise known as
"wall paper"—for peoples' phones or tablets? Be creative, and
try to get ideas by looking at others. If your idea is really good,
you can even charge people to download it, so that you can
make an income from it. Consider this for a moment; it's a
truly new market. If you could find a way to send images of
your own through your phone app in a way that is fun and
entertaining, you could earn real money without doing any
selling. There are many different approaches to this, like start-
ing with a free app and upgrading it to a paid one, but take
your time; think and dream about it and, most importantly,
play with other apps to see which ones you like and don't like,
and that will point you in the right direction.

foursquare

The title of mayor (on foursquare) is given to the person who checks in the most times at any one location.

This is another new platform that is fairly simple in its concept. If you have the application on your smartphone, you can "check in" when you walk around to different places, for example from the grocery store to school, or to a bar or a concert. That means you are using your phone's global positioning system to determine where you are. For example, if I am on 23rd Street and Broadway in Manhattan and I click on "places" in the foursquare app, I'll see Madison Park and lots of delis, restaurants, and retail stores. Using a vast and constantly updated data bank, the phone can tell what's around you. If I walk into a deli or go to a park, I can "check in" there, meaning that I can click on the name of the park and choose that as my location. I can also add a comment. Then when other people check in to the park, they can see my comment, and it may even help them. Perhaps I might comment, "Don't eat the hotdogs at the stand on the northeast corner. They taste terrible," or I might say, "Watch out for the rats coming out of the hole underneath the sculpture in the middle of the park." Those comments are a way for people to tell each other what they think is good and what isn't at any particular location. But there are many more components to foursquare that have contributed to its popularity.

Becoming Mayor

If you check in to a location—say the park or a deli—multiple times, you may become the "mayor." The title of mayor is given to the person who checks in the most times at any one

location. You cannot check in more than once a day, to keep things fair, and you have to actually be there. If you become the mayor of a location or of many locations, anytime someone checks in at that spot, they will see that you are the mayor. This simple feature has caused people to check in everywhere and compete for the title of mayor. But there is another component that stores use and you can use it, too. Let's say the local pizza place is on foursquare, which it most likely will be. The owner of the pizza place can post rewards on its place marker. For example, it could announce that whoever is the mayor of the pizza place gets a free slice or something like that. That makes more people who go there regularly want to "check in" so they can get their free slice. The pizza place benefits because more people are seeing check-ins at their restaurant, and it is becoming well known as a result. Like Facebook and Twitter, many of your friends may be on foursquare, and they will be able to see what you are the mayor of. Knowing that you go to certain places so often will make them consider checking them out as well.

Artists on foursquare

But how will you, an artist, use this platform? In several ways. To begin with, you can enter your own location, and it doesn't cost anything. Let's say you want to put your studio on there. You simply enter the information and a name, probably your own, as the name of the studio. Then you can check in there regularly. Every time you check in to your studio, you have the option of telling your friends on Facebook with one click. That means foursquare creates a post on your Facebook wall with a little map showing where you are. You can make a comment too, like "Working on my giant robot sculpture today,"

> *There are many blog services out there, but the best ones as of this writing are Wordpress and Tumblr.*

which should get you a few comments. As you continue to do this, more and more people will remember where your studio is. As the owner, you can announce parties, post pictures, and create events. Also, when you visit a gallery or another artist's studio, you can comment on it and people will see where you have been.

The term "social networking" is appropriate for four-square because you are not just talking about your studio but other studios as well. If you comment on a show in a gallery or a museum, a map of those spots will pop up on your Facebook wall along with your comments, and others will comment back, so the community grows because of interests shared by artists, collectors, and friends. It's like a game in a sense, but with the added value of helping you publicize your exhibits and your studio, which in turn can drive sales of your artwork up by increasing visits to your studio and creating a stronger community to support you.

Wordpress

There are many blog services out there, but the best ones as of this writing are Wordpress and Tumblr. The reason for the great success of Wordpress, a relatively new blogging site, is that it can be used to create so much more than a standard blog because it includes plug-ins for adding all kinds of features to your blog. This makes it very dynamic and allows you to change the look and feel of your blog as well as its functionality. You can easily integrate it with other social platforms so that whatever you write on your blog appears on those sites

as well. There are new features being added constantly, which explains why it is one of the most popular blogging sites out there.

Why do you need a blog? For several reasons: You can use it to put up new images of your work with descriptions of what you are doing, you can use it to connect with other bloggers, and it can take the place of a web page by giving you the ability to update all of your artwork. Also, if you like writing, it can help you get the attention of a publisher, and if you attract enough followers, you can even earn a living with it by selling advertising space on your blog. You might feel like keeping a blog is overwhelming or unnecessary, but it's one of the most important elements of your social media arsenal, as it has the ability to create conversations and build interest. In chapter 2, I talk about artists who make a living using eBay, and a blog can play an important role in driving up your eBay sales.

LinkedIn

LinkedIn is a professional networking site, and you should consider adding it to your list of social media tools, because it has a slightly different function that sets it apart. Originally, it was intended for businesspeople trying to meet others in their fields. It works in a way that is similar to Facebook; you begin by entering information that is related to your work and, like Facebook, LinkedIn has the power to lead to introductions to curators and others who can help you. The concept of LinkedIn is that you describe your business and then, as you become friends with others, you become connected to their networks, and the concept of seven degrees

of separation to almost anyone comes into play. For example, let's say I had a show at the Whitney Museum of American Art (which I did) and that one of the curators at the museum accepted my invitation to be connected on LinkedIn. Now, I could go to my LinkedIn profile, and look through all the curators' connections. I may see people there that I want to meet. Instead of just writing to them, LinkedIn requires that I ask for an introduction. That means my friend who is a curator at the museum has to send a note to introduce me to them, and LinkedIn makes that process very easy. For the serious artist who wants to make connections the way a businessperson does, this is a great resource, and it's one that you should not be without.

YouTube, Vimeo, and Video-Sharing Websites

Video can and should be a part of how you communicate with the world about your art. This can take many forms, so you do not have to be a video artist to take advantage of this medium. A YouTube channel is easy to create, and it's free, so I suggest you sign up for one today. If you are already doing this, fantastic; if not, it's as easy as creating a Facebook or Twitter account. Once you do that, you can easily make and upload a video. You can use a phone camera or a small consumer digital camera.

Video Studio Tour

An easy way to get started is to give a tour of your studio. This makes it easy, because you do not have to be in front of the camera. Just turn it on and spend three minutes or so walking around your studio and talking about it. Tell people a little bit about what they are seeing; if something is recent or in progress, talk about it. Be as quirky as you like, be relaxed, be as you are. There is no need to perform here or do anything that is not your style, so just talk and, if possible, be enthusiastic.

If you take this approach, you can probably see how you could make a video almost every week. These videos could be posted on your Facebook account as well as your Twitter account and blog. Everyone loves videos, and not only will it get responses, it's very much like a studio visit. So take advantage of this powerful medium and begin making videos and sharing them. You can shoot videos of almost anything, so there's no need to limit yourself to studio tours. You can make a video of a place that inspires you, or a time-lapse sequence

> *The key is to be consistent in your video production when possible; a good goal to set for yourself would be to create one video or more a week, keeping them under three minutes each.*

that shows an artwork being made, or anything else that relates to your art.

Consistency

The key is to be consistent in your video production when possible; a good goal to set for yourself would be to create one video or more a week, keeping them under three minutes each. You don't want to make videos that are too long because people will get bored and impatient. In this new, fast-paced world of online communications, video is the quickest way to communicate a lot of information, but it also has to be brief to have an impact. There are, of course, exceptions to this rule, but it also makes it easier for you if you concentrate on making something quick and easy as opposed to a more elaborate production that could take a week or more to produce. The value of video is huge and social media gurus talk about it all the time as one of the best ways to reach your audience. I know that when I want to learn something about a new program or anything computer related, I really don't want to read a long text about it, or even a fairly short one; I would rather watch a video tutorial by a nonprofessional who narrates while clicking around their computer screen explaining what they are doing. I learn very fast that way, as do most people, because it is visual and easy to understand.

eBay

By now, everyone is familiar with eBay, a huge, largely auction-based marketplace where many artists have sold their

work. In general, when an artist sells his or her work at an auction like Sotheby's or Christie's, their market value is established. Similarly, if you sell work regularly on eBay, it will increase in value over time.

For example, let's say you put up a small drawing or painting and it sells for $50 at first. As long as your art continues to sell for about the same amount, that value is being established as what people will generally pay. But if you keep selling your art on eBay, week after week for a year or more, you will see the prices rise slightly, especially if you are promoting your artwork on your blog and Facebook. When the prices rise, you are establishing real value for your work. You will read more about artists who have done exactly that in chapter 6.

Putting Everything Together: Hootsuite, Tweetdeck, and More

Perhaps all of this sounds overwhelming—as it probably should—but there are ways to simplify all of the social networking you'll need to do to promote yourself and your art effectively. One way is to hire someone. That person is called a social media manager, and this is one of the fastest growing jobs right now. Because small businesses everywhere are realizing that the phone book and traditional ads are not cutting it anymore, they are hiring social media experts to do all their tweeting, blogging, and Facebook status updates. That is an option for you; however, you could easily do it all yourself using a central hub, which I will explain in a moment. Another option is to become a social media manager yourself. You could make a good part-time income or even take it on full time. I will explain this as well.

The way to bring it all together is through a central system, or dashboard. That means that all your social media platforms—Facebook, Twitter, YouTube, LinkedIn, Wordpress or Tumblr, and more—can be controlled through one, easy-to-use program.

Dashboards

The way to bring it all together is through a central system, or dashboard. That means that all your social media platforms—Facebook, Twitter, YouTube, LinkedIn, Wordpress or Tumblr, and more—can be controlled through one, easy-to-use program. The program that I use is called HootSuite, but there are others, like Tweet-Deck. What these programs do is organize all of your social platforms, simply and elegantly. If you use HootSuite, which at the moment has more tools that TweetDeck, you will be able to manage all of your platforms by logging into them all at once. Then you have several choices. You can send a tweet just once, about your art or an upcoming show, for example, and it will automatically appear on every other platform with the touch of a button. That way you do not have to spend time looking at each one; you just enter an update or a new image you made and it goes out everywhere. That saves you lots of time, so that after under thirty minutes, not only will you have updated all your sites, you'll have also poked around and "liked" other peoples comments or made your own comments. It is called social networking for a reason, so you have to remember that it's not all about you; it's about the community you are in. Just as you like to receive comments on your updates and new images, so do other people. If you comment on their posts in a way that shows a sincere interest in them, they will take an interest in you as well. This is what the new online community is all about, and it has

fundamentally changed the way products are marketed. It is now a give and take that people want, a way to give and get feedback on everything from travel photos to their latest interests and passions.

Daily Work

You should make it part of your daily social networking routine to look at the work of friends and other artists as well as any institutions that have Facebook pages and comment on what they post. You can spend as little as fifteen minutes a day on this, but it makes all the difference in the world. When other people—including those associated with major institutions—see that you like their post or comment, they will remember who you are and will be inclined to comment on what you are doing. This is essential because through it you are becoming part of a community, and you must contribute to that community if you expect others to appreciate your posts.

Programs like HootSuite can help you to do much more than just easily post a message across platforms and organize your social media accounts. They can also send out tweets and messages that you compose in advance, and they can send them out on a scheduled basis.

Is It Cool and Authentic?

Recently, a friend of mine was opening a small store and we were talking about advertising his business. I told him that it was essential that he have not only a Facebook page, but at least a Twitter account and foursquare account as well. When I elaborated, he said, "You're making me feel old"—and he is in his early thirties.

> *If you want to become fluent in social media, you can. It's really not that hard, but you have to have the will to do it.*

This is something you may be feeling if you're over thirty, because most of this is new to you, but let's look at that statement for a minute. *Why* was I making him feel old? Because he wasn't familiar with online promotion and he felt that it would take him a while to learn it, so he was resisting evolution and change. Of course that is very natural and it's understandable. People have the same reaction to smartphones, but in spite of the learning curve, I see older people tapping away on their smart phones every day. If you want to become fluent in social media, you can. It's really not that hard, but you have to have the will to do it. You also have to realize that you're not alone, and there's a lot of support out there for you in the form of books and videos.

Sincerity

As I continued to talk with my friend about social networking, I told him about HootSuite and how he could spend a small amount of time each day on it, or even just one hour a week, by scheduling all his tweets in advance announcing specials he would be offering at his store. In response to this he said, "That sounds kind of bullshitty." When I asked what he meant, he said, "Well, when people are tweeting and updating their pages, you assume they are actually doing it, but if you schedule all these things in advance, it's kind of false."

This is an interesting opinion, and it's one that you might share. Is it somehow disingenuous if you schedule a message to go out at a certain time instead of always typing it in at the moment? I think there are several ways to interpret his state-

ment. He may be saying this out of fear because he feels it will be too difficult to learn. It may be another excuse not to get into online marketing and social networking. The fear of getting too involved could certainly be an issue as well. Finally, he might be saying this because it upsets his own Internet experience; he can no longer know whether people are posting things in the moment or just scheduling all their posts in advance.

No matter what the reason for my friend's reaction, I do not see composing posts in advance as somehow insincere. If I am scheduling a tweet (which I do) and I am talking about an exhibition I saw that I loved or a new work of art I have made, I am being honest in what I'm saying. I could schedule posts like that all week long, and still be truthful. In fact, I am really just making announcements. The only aspect of social networking that requires that you interact in real time is "liking" or commenting on someone else's post. This is when you have to contribute to the community by interacting with people in real time and investing the moment you have as you type on the keyboard.

A Warning

Everyone has a different reaction to the thought of getting involved with social media tools like Facebook and Twitter and using them for the first time. These reactions are often age related, because people in their teens through their late twenties are very tech savvy (or at least that's how people over thirty think of them). Children, on the other hand, are not so much tech savvy as fearless. Digital media and smartphones can be used by toddlers and young children are becoming very familiar with the concepts of poking around

on a touch screen to write, download, play, and do research. That gives the newest generation a head start, not because they are smarter, but because they are learning about these technologies earlier in life, when they are not intimidated by them.

Chapter 5

Advertising Your Art on the Web

T he main outlets for promoting artwork have always been magazines and other print publications that are read by collectors, but Google AdWords represents a new wave in advertising. The way it works is that you first decide what you want to advertise. If you're an artist, you'll probably want to advertise your website. The product you're trying to sell is your art, but you are promoting your website so that people will visit it. When you've gotten people to visit your site, you have to think carefully about what you want them to do there. Most advertisers want people to sign up for their mailing list, and that's a good idea. (In chapter 14 we talk about how to create a mailing list.) But you may want to do something different. Perhaps you want people to buy a print or comment on your

art. Whatever it is that you want people to do, you can make it happen by getting them to visit your website.

Placing an Ad with Google

To begin the process of placing an ad with Google you can simply read about it by searching for AdWords online. Google makes it easy for you by offering a phone number you can call to discuss your ad with a live person who will walk you through the whole thing. If that service is no longer available at the time you are reading this book, there will be a tutorial that shows you how to get started.

The first thing you need to determine is how much you want to spend. You can spend a dollar a day, or more; it's up to you, and you can change it or cancel it at any time. The way

people will find your ad is through the words they type in to search for something, for example, your name, or "art for sale," or something similar. What you are doing is setting up a campaign for your ad.

Your Ad Campaign

The elements of an ad campaign are the design of your ad, the amount you want to pay, and the keywords you will use, meaning the words that people will have to type when performing a search for your ad to pop up. This may sound a bit complicated, but it really isn't once you get going. When you make the ad, you'll write a few very short lines to get people to click on it. I just Googled "contemporary artist" and this came up first in the ads on the right hand side of the screen: "Thomas McKnight ORIGINALS paintings, prints and more for less. Official site for Thomas McKnight." The ad links to an artist's website, the first page of which shows one of his images, with a list of the prints he has for sale right below it, along with prices and his phone number. The site is well made and answers any questions you might have about his art. He has clearly made a successful business out of selling his works and, based on the information on the site as well as his professional presentation, it looks like he's doing well. It turns out that he is not far from where I performed the search, and that is not a coincidence.

Location Targeting

You see, when you write your ad, which should look something like Mr. McKnight's, you can also decide where you want people to see it. For example, he is probably trying to reach people within a certain radius of his studio. But in your

> *Let's say you want to spend $30 a month, which is pretty low to begin with. That's about a dollar a day. The way it works is that you only pay when someone clicks on your ad.*

campaign data, which you'll enter when making your ad, you can also use criteria other than location, like what words should make your ad pop up when typed into a search engine. This is not something you master right away; it is something you adjust and manipulate over time, until you are getting what you want (effective click-through) for the least amount of money.

Your Budget

Let's say you want to spend $30 a month, which is pretty low to begin with. That's about a dollar a day. The way it works is that you only pay when someone clicks on your ad. You can even decide how much you want to pay. Let's say you decide to pay 10 cents a click. You may get a notice saying that is too low, but let's imagine the amount of 10 cents per click is accepted. Every time someone clicks your ad, you will be charged 10 cents. If ten people click your ad in a day, your ad will not run until the next day begins because you just spent your dollar a day limit. Because you're paying for that click, you want to be sure that your first page looks really good and gets the response you're after, like a phone call or a purchase or a new e-newsletter subscriber. If you increase your budget to $60 a month, you could potentially have twice as many people clicking on your ad. But if you only want to pay 10 cents, you may not get any clicks at all, because other artists are competing with you for the top spot and they can drive up the price; if they are willing to pay 50 cents or more, Google will show their ads first.

One way to get around guessing how much to pay for a click is to make it automatic. That means Google will determine the best rate for you to pay so that you will be competitive, usually somewhere between 75 cents and a dollar. That may seem like a lot, but it really isn't. If you are paying $60 a month for your ad, you could get 60–80 clicks for that amount. If those clicks generate one sale, you will probably be doing well. Google offers support for all aspects of AdWords, so don't be intimidated or overwhelmed. It's as simple as filling out forms and following directions.

Facebook Ads

More and more I am seeing ads by artists on Facebook. This is a new way to reach an international audience, or a specific audience bounded by your location or other criteria. When I see ads on my Facebook page, they are all related to the arts somehow. There are ads for galleries, museums, artists, and yoga businesses. Why do I get those specific ads? Because when you use Facebook, you are constantly feeding personal information into it. You tell Facebook where you went to college, where you work, and what your interests and hobbies are. That is a lot of information to give out but, remarkably, millions of people do it.

The Facebook Advantage

Facebook's popularity and its ability to glean personal data from its users give it an edge on Google AdWords in some ways. As of the writing of this book, there are more than 500 million active users on Facebook, and it's growing all the time. Google has access to more people, with about 100

million searches a day and growing, but Google can't target a specific audience as effectively as Facebook. That's because Google does not have all the personal information about you that Facebook has.

Also, when you make an ad for Facebook, you can use a picture, and for an artist that makes a big difference. Ads created for Google AdWords only use text, which makes it very clean looking when you search, but not as visual as Facebook. Facebook ads work in more or less the same as the way as Google AdWords. You pay per click and the process of setting up a campaign is very similar. The big difference on Facebook is that you can include a picture with your ad and the ways in which you can define your search.

Advanced Targeting

Since Facebook knows its users' birthdays, hometowns, schools, and interests, your ad can target people with very specific interests and backgrounds, making Facebook something really new and precise in advertising. Never before have so many people so willingly provided so much information that could be accessed by advertisers. For ages, advertisers have been trying to figure out how to better know and target their audiences, and here it is—all the work done for you, all the data collected.

Is Facebook more effective than Google AdWords? I think so, but Google AdWords are also very powerful in another way. Facebook may have millions of registered users, but in order for them to see your ad they do have to be *on* Facebook. With Google AdWords, all you have to do is perform a search on Google. That's very effective because it means that people are actually looking for something, so they are more likely to be

actively interested in your ad, whereas on Facebook, your ad appears and draws interest, but the people who see it, are not actively seeking what your ad has to offer. If you can afford to experiment with both Face-book and AdWords, that's what I'd recommend. If not, I would start with Facebook.

Your Campaign: Getting Started

First, take a deep breath and know that this is not a complex process, though it may seem so at first. All you are doing is placing ads targeted to a specific audience on the Internet, so that your art will become more visible and attract buyers. You are doing this instead of placing ads in traditional media like magazines or putting up posters around town because not only do Internet ads reach people worldwide, they can target a specific audience.

The next step is to begin with either Google AdWords or Facebook. Let's say you are beginning with Google Ad-Words. Just search for the phrase "Google AdWords" and you'll find the site very easily. The best way to get started is to call them up on the phone. If you would rather do it all online without speaking to someone, then you have that option as well.

Once you have opened an account, you have a few decisions to make. The main one is how much you're willing to spend. How much can you afford to spend each month? Your budget is important because it will determine how far your ad will reach, and if you decide to spend less or more in the future, you can see how that affects your results and compare.

Once you've made that decision, you can begin to create your ad. In the case I mentioned, where I Googled

> *The text of your ad can't be very long, but you can experiment. You can make four or five ads, run them all at once, and see which ones get clicks and which ones don't.*

"contemporary art," the first ad that popped up in the right hand column of the Google search page was "Thomas McKnight ORIGINALS paintings, prints and more for less. Official site for Thomas McKnight."

Let's examine this ad for a moment. I found this by typing in "contemporary art," so we know he probably chose these as keywords. The keywords are the words you'll enter when creating your AdWords account so that people searching for something in particular will find you. Thomas McKnight's ad mentions his name twice, which is probably unnecessary. He is very traditional in his approach as an artist, and yet he uses Google AdWords to advertise, so they must work for him.

If you don't have a history like his—he has had artwork commissioned by the White House and has pieces in the permanent collections of the Metropolitan Museum of Art and the Smithsonian—you might want to take a different approach. If your work is abstract, or figurative, or something else, you might want to say that in your ad. The text of your ad can't be very long, but you can experiment. You can make four or five ads, run them all at once, and see which ones get clicks and which ones don't. As for the text, start with something easy, like your name and the kind of work you have for sale, and then create more ads that speak to different parts of your art practice that you think people might be interested in. If you paint landscapes, say that, and if you're a sculptor or performer or conceptual artist, say that too. The idea is to play with it and experiment.

Watching Your Ad Work

Once your campaign is up and running, you can log into your AdWords account and see exactly how your ads are working. You will be able to see where the traffic is coming from, which of your ads performed the best, and which keywords were the most effective. As you look over that data, you might notice that some keywords worked better than others, and you can judge this by how many seconds people stayed on your home page after clicking on your ad. If they stayed for less than two seconds, then chances are they knew right away they were on the wrong page; that means they were searching for something else. Based on these results you might want to stop using some keywords and try others instead. Your goal is to make each click count, and that means having people stay on your page for five seconds or longer, which would indicate that they are actually interested. The other criterion that you can adjust is location. In the case of the Thomas McNight ad I discussed, he probably specified an area around his studio as the target location for his ad, or maybe even several states around his studio. That way, the people who found his site could actually go visit his studio if they wanted, and that's a big plus. Those people would come to think of him as a local artist whom they could meet. These are all considerations when creating a Google AdWords campaign. You can find the help you need to set up and maintain your campaign online, but Google also has a customer service phone number you can call. It's worth noting that Facebook does not offer this kind of personal support as of 2012.

To start a Facebook campaign, you need to have a Facebook account. When you are on your Facebook page, search for "Facebook ad," and you will find easy instructions on how to get started.

A Facebook Campaign

To start a Facebook campaign, you need to have a Facebook account. When you are on your Facebook page, search for "Facebook ad," and you will find easy instructions on how to get started. In many ways, it's very similar to the Google AdWords setup process (probably because that's where they got the idea from). As I said earlier, the difference with Facebook is that you can include a picture and you have more information about the people you are reaching. Now the fun begins. You begin by creating an ad for your campaign that includes a photograph (uploaded from your computer) and also some text (which you'll have to write, and which will appear next to it). It may seem obvious to you, as an artist, to include a picture of your art, but that depends on how well your art reads when the dimensions are so small, about 1" x ½".

Examine Ads That Get Your Attention

Look at other ads and see what jumps out at you; this will help you get a sense of what gets your attention and what doesn't. I just went to my Facebook account page and found two ads by artists on there, which is no coincidence. The first ad has the artist's name at the top of the ad, and the text—to the right of the image—says "View Original Art by Award Winning Artist [her name]." In the second ad, the artist put his name at the top followed by the words "View the Art of Figurative artist [his name]." In both cases, the artist included

an image of their work. Now when someone looks at that ad, they have two options, as opposed to a Google ad, where the only way to interact with the ad is to click it. On Facebook, there is a small thumbs-up symbol underneath the ad with the word "Like" next to it, followed by a number that tells you how many people have "liked" it on Facebook. In addition to clicking on the ad, which links to your website or Facebook page, people can also "like" your ad. You see, people may be too busy to click on your link and look at your art, but if they are getting enough information from your one sentence and the picture next to it, they can just click the thumb and "like" it. They don't even have to look at your page, and you get that person's name. But how do you get their name?

In the case of both of the artists' ads I described, the ad links through to their Facebook page instead of their website. OK, it gets a tiny bit complicated here. Either of those artists could have made the link go straight to their website, so why did they choose to send people to their Facebook page? For one thing, they would not get the "like" link below their ad if the ad linked to their website. Having that "like" link is very nice because you will be able to see the individual's name without their having to sign up for your mailing list, which takes much longer. Then, you can send a newsfeed story on Facebook to all the users who liked the page. However, this is where Facebook keeps changing policies, which we can expect endlessly, so it may be different when you are working on your ad, but it is the same idea. Remember, through experimentation you will learn most of this, not by understanding it all first, but by jumping in- make an ad.

> *Don't worry if this seems confusing; when you go to Facebook and begin the process, it will guide you through many of the decisions you have to make.*

As with Google Ad-Words, you will be asked to make a decision about your search criteria. On Facebook, you have much more to choose from. You can target certain areas, like the city or state you live in, or you can target Facebook users who are artists, collectors, curators, or even people with certain birthdays, meaning people in a particular age group. There are many, many criteria to search through, so take your time on this step, but also remember that you can always make changes; nothing is set in stone and Facebook itself keeps adding new tools all the time. And don't worry if this seems confusing; when you go to Facebook and begin the process, it will guide you through many of the decisions you have to make.

Chapter 6

eBay and Selling Art Online: Two Cases

T raditional methods still survive, but options are multiplying all the time for selling your work. Rags-to-riches stories are much more common today because the Internet has provided loop holes in the playing field so that emerging artists can suddenly gain fame through a blog or a viral video or other methods.

Abbey Ryan, the Painter Who Made a Living on eBay

The way art is marketed and sold keeps changing with the times. Now with eBay, Amazon, and other retailers, wholesalers, and trading services online, you have many, many options, and you can use one or several of these resources to sell your work.

To give an example of one approach to selling art online, I interviewed an artist named Abbey Ryan, who uses eBay

She is in her studio — which is not in a major city — working away, shipping her art all over the world and making a living at it.

to sell her work. Her process is fairly straightforward and very profitable. She began the practice of painting one canvas every day, a small, square canvas that was always the same size. The paintings were usually of a piece of fruit or a minimal still life. After she finished each painting, she would post it on eBay and also on her blog. She also sent out an email to friends telling them what she was doing.

For the first year she did this, the minimum bid on her paintings was around $50. At first, her paintings sold for well under $100 each on eBay. In fact, for a whole year, her paintings were selling for under $100 each, and some didn't sell at all. But after a year, her prices began to increase because people were bidding higher on eBay. Now three years have gone by and each painting sells for $800 to $1,000. Since she makes over three hundred paintings a year, she is bringing in at least $200,000 a year from this. For some artists, that might seem like a dream. Here she is in her studio—which is not in a major city—working away, shipping her art all over the world and making a living at it. There are other painters and writers who have used the Internet to create one work a day and get the word out to potential buyers. In 2011, there was a "draw every day" campaign running on Twitter, and many people simply took photographs of their daily drawings and uploaded the picture to their Twitter accounts. Commitment to this kind of a process can work well for writers and artists, because it helps them to put their work out there every day and feel supported by others doing the same. It's also a great way to get constant feedback on your artistic output.

Why Success for Abbey Ryan?

There are many painters who follow this type of process, but Abbey Ryan has been particularly successful, so let's examine why that is. To begin with, she was very consistent in her approach, especially during the first year. To put up a painting on eBay every day takes more than work; it takes dedication, especially when the prices are low and people aren't bidding. In her first year, Ryan worked very hard and wasn't making much money. Could you do that?

Ryan's commitment was certainly one of the keys to her success. But let's look at how she managed her online market. She was using three sources at first: eBay, a blog, and her website. That's a total of three forums to update and manage every single day. It wasn't very hard work, but she had to learn how to do it, and that takes time. That was some of what she learned and worked through in her first year. Also, she wasn't shy about promoting her work and sending links to blogs and news outlets that might write about her. Now, if she gets press anywhere, she highlights it right away on her website and blog and shares it with the world. She has added Facebook and Twitter to the mix now and also offers giclée prints of her work at $50. All of her knowledge on this type of selling was gained in less than three years, so no matter what age you are or where you live, in a few years you could potentially have a whole new education and career.

Lessons from an Independent Artist

It's important to remember that this is not the only kind of art that Abbey Ryan produces, but it is how she earns a living. She works on other art projects in addition to her daily paintings, but her daily paintings remain consistent and familiar.

In other words, she doesn't experiment all the time with her daily paintings; she takes greater risks in her studio work that is not on eBay. The images she uploads every day are similar, and her audience knows what to expect.

There are many lessons to be learned from Abbey Ryan's story, but more than anything it shows what can happen in today's online markets, no matter where you live in the world. At the very least, it proves that eBay can be a legitimate resource for selling your work and earning a living. If you want to make a start in this kind of market, there are several things you take into consideration. Begin by thinking about what kind of work you could sell online, consistently, every day. Imagine yourself doing it. Does it feel exciting, or does it feel overwhelming? If it seems like a possibility for you, then the next step is to begin to formulate your strategy.

Commitment

You should begin by making the decision to commit yourself to at least a year,

If you want to hear the entire interview with Abbey Ryan, you can listen to it on my website, yourartmentor.com.

but three years is better, because you can see how Abbey Ryan's success grew very slowly. Next, you have to choose a platform for your daily postings in addition to eBay, like Facebook, Twitter, Instagram, or a blog. I would choose just one of these to start with, not all four. Twitter is one of the easiest, because you can write a small sentence and post a picture. If you want to write more, then you should choose Facebook or a blog. If you only want to post an image, Instagram is wonderful. Ryan started with a blog because that way she could write more about her work. She told me that at first she thought she didn't need to write about her art; she felt that the image said it all. But then she found that people wanted to know more and that it helped to sell the work. So if you are armed with dedication and knowledge of eBay and blogging, you may be ready to go. If you want to hear the entire interview with Abbey Ryan, you can listen to it on my website, yourartmentor.com.

Your Niche: TMNK and Selling Your Art on the Street

Perhaps you think that this approach won't work for you, because your work isn't like Ryan's. Well, there are plenty more artists I could give as examples, like the graffiti artist who goes by the acronym TMNK, which stands for The Me Nobody Knows. He also sells work on eBay and operates as a free agent for himself, and he has a very different presentation from Abbey Ryan. As a so-called "street artist," he has created

a certain persona for himself by calling himself "nobody." However, if you take a look at his website and blog, you can see that his efforts are getting quite sophisticated, and his style of presenting himself as a nobody is increasingly fine-tuned. In an interview, I asked him about how he began his career, and his beginnings are similar to Abbey Ryan's but with a few key differences. He had worked as a graphic designer for ad agencies and decided to quit his job and begin selling his art on the street. He was living in New York at the time, so he was selling his art there. The laws differ from state to state and country to country, but usually you have to get a sales permit, which is fairly easy, and find out what the laws are for artists selling work on the street. In New York almost anyone can sell their work on the street in Soho and in front of museums and many other places, getting some of the best real estate in New York for nothing! Normally, when I mention this to artists, they don't accept the challenge, but it can be incredibly lucrative.

TMNK sold his work on the street and still does, but he also began selling it on eBay. Like Ryan, he posted things regularly and sent out emails to everyone telling them what he was doing. Over the course of a few years of promoting and selling his art with only the street and email as his show space, he built a career as successful as Ryan's. The difference between TMNK and Abbey Ryan is that his art is graffiti-based and he used the streets as a way of building a fan base and driving sales. If you search for him on the web, you'll find his work, just like his fans do; you could say that that's his main studio, because that's where most people find him. I am often asked if artists can sell work online. The answer is yes, but it depends on how they do it. TMNK puts his artwork on eBay all

the time and its value is increasing. But it's also a marketing tool. A lot of people see items listed on eBay. The value of his work continues

Your online sales can also extend to other items, such as print-on-demand books, prints, and DVDs

to grow and as a result he has begun to move away from eBay, as Abbey Ryan has done as well.

eBay as a Launching Pad

After at least three years of selling on eBay, and as their fame and fan bases grew, both Ryan and TMNK began to get offers for shows. TMNK got an offer from one gallery in Milan and one in Norway. Both of those shows sold out, and now he's making work for another one. Selling on eBay and on the street on a regular basis helped him to launch his career. He doesn't have a big gallery representing him, but he has enough shows now that he no longer needs eBay the way he did. He has gone from what may sound like a modest beginning to driving a jaguar and living in a half-million dollar home, and he has an assistant in his studio. Abbey Ryan has also pulled her work off eBay, or is at least putting things up for auction much less regularly, as galleries have begun to contact her.

So there you have it: two examples of artists who went from self-promoting on eBay to having galleries selling their work. This is something you can do, too—starting right now!

Online Choices

Your online sales can also extend to other items, such as print-on-demand books, prints, and DVDs. If you are trying

‿ sell video work or prints, this may be a good option for you. With prints—by which I mean high-quality printouts of photographic images of art work—you have a lot of choices. You can make prints of paintings, drawings, and even sculpture, because the prints are being made from a high-quality digital image. You do not have to make work just for prints; you can photograph anything, as long as it looks good.

That first image that is taken with a camera is crucial, because it must be perfect. That means you shouldn't do it yourself unless you are a professional photographer with a light kit and umbrellas. The reason for that is when an image is reproduced, not only must it be in crisp focus, but also the colors have to be right, and it has to be perfectly square in the frame or cropped in Photoshop so that the image is squared. I know you have been using your iPhone or camera to reproduce your art, and that's ok as well, but if you experiment with hiring a real photographer who reproduces artwork, it will make a huge difference in how your work is perceived online.

Printing On Demand

The next step is to find a printer who can print the image on demand and even ship it for you. There are many places doing this online, but I think it is best to use a printer near you, so that you can talk to them in case there are any problems. You should ask your local printer if they can print on demand, meaning that as soon as someone orders a print, you tell the printer, and they print it and ship it from a digital file they have of yours. This is a very economical way of working because you don't have to pay for the printing until the print is sold. Abbey Ryan and TMNK both sell prints, and they are probably using a similar service. There are new printers springing up all the time; it's an industry

that's growing very fast, so take some time and search locally as well as regionally to find a printer, then call them and ask all the questions you want about getting started.

Video On Demand

There are also great on-demand services for those working with videos. One is called Create Space, and they sell books, CDs, and DVDs through Amazon. This is standard practice for selling independent videos. If you contact their website, there are instructions that will walk you through publishing your video for sale, but this is how it works: First, you make your DVD and burn it onto a blank DVD-R, using your computer. Then they will ask you to upload a design for the cover. They give you a template so it's not too difficult, though it does help to know a bit about how to use Photoshop. After you upload your video cover, you will need to mail them the physical DVD that you burned on your computer. They will make a copy of your DVD and mail you back a finished sample (at no cost to you as of this writing) so you can see what it looks like. After that, they list your DVD on Amazon so that people can search for and buy it, and Create Space makes and mails the videos when the orders come in. If you are charging $25 for a DVD, you will get a total of about $9 dollars, and if you give Create Space your bank information, that money will be directly transferred into your account.The reason I put a DVD on Amazon is because after I gave a lecture on professional development for artists at a library, the librarian asked if I had my lectures on DVD. I said I could make one from a previous lecture that had been recorded and bring it to her, but she told me the library was more comfortable buying from a third party like Amazon. I went home, figured out how to use Create Space, and I sent her an email with the link to

> *An executive once told me that marketing anything is simply telling people over and over what it is that you do, so that one day, when they decide to buy a good that you produce, or a service, your name will be one of the first they think of.*

order my DVD. Not only did that library buy it, they also mentioned it in their newsletter, and other libraries began buying it and requesting that I lecture at their locations! If you want to see the DVD I made just search Amazon or the web for "Income Strategies For Artists." My son is now making a yoga video with this method. Online services like Create Space are a very easy way to make your commercial videos available to everyone.

Print-on-Demand World

Now that people are able to self-publish their own books, and often make more money than they would with traditional publishers because they are doing all the marketing and promotion themselves, the print-on-demand method is changing the publishing world as well.

The up and downside of the print-on-demand process is that you alone must direct customers to your product. In the case of the video that I made, I sent the Amazon link to libraries and schools that might want to buy it, and those became the majority of my DVD sales. In the case of the yoga video my son is making, he has a YouTube channel and a Facebook page with many followers, and he can advertise to this audience for free. The new social media tools are a big help when driving traffic to your on-demand products. An executive once told me that marketing anything is simply telling people over and over what it is that you do, so that one day, when they

decide to buy a good that
you produce, or a service,
your name will be one of
the first they think of.

I like Instagram; I use it on my phone, an Android smartphone, and I love looking at the images.

Consultants

In this chapter I have talked about how artists can use Internet resources such as eBay and blogs and on-demand services, but other markets for selling your work are still being created. It seems that every day there is a new social networking site—some are just for artists— that combines many of these services, though it is important to compare prices and read the fine print before signing up so you know how much you will actually get paid for each item sold.

Instagram

New social platforms are not better just because they are new, but because they are effective in a new and clear way. A recent example that is valuable is Instagram, a service much like Twitter, but it is only images that you upload, very simply. The beauty of Instagram is that your news feed of people you are following is all images. So you respond only to images by liking them. For artists and anyone interested in art, it is a place where striking images can be found. Even NPR radio has an Instagram account that they communicate to listeners with; find it, and look at their pictures. Like other platforms, this is one more way to create an awareness of you and your work so that you can sell it. Personally I like Instagram; I use it on my phone, an Android smart phone, and I love looking at the images. It is a resource full of rich inspiration, like a giant picture file from all over the

world, as well as a community that can comment or like each others images. It is entirely aesthetic, it is about looking.

Hotel-Motel-Hospital Collections

The market for selling prints to consultants, who, in turn, sell prints to interior designers or hospitals and hotels directly, is growing all the time. Some hotels and other facilities now have digital galleries where customers watch a screen that plays a slide show of paintings and art for sale. The dealer can stop the slide show and talk about the work. Once customers decide what they want, and in what size, the dealer sells the print and has a printer make and ship it to the customer's home. We will talk more about this powerful new form of selling art in chapter 8.

Chapter 7

Art Fairs: Small and Large

There are only two major art fairs, and they are The Armory Show and Basel. There are, however, small DIY (Do It Yourself, usually run by artists) or small commercial fairs that travel around neighborhoods where major art fairs occur. Art fairs are undergoing big changes. The two big fairs are extremely exclusive. Basel Art Fair, for example, only takes certain galleries in their fair and has VIP openings that cater to wealthy collectors. Generally, fairs like Basel are not a good place for moderately successful artists to promote their work. The reason is that the gallery directors at these fairs only want to talk to collectors and sell the art on display, and are not interested in meeting new artists. In fact, artists tend to get in the way of delicate new meetings between directors and their potential clients.

Meeting Gallerists at Art Fairs

Most gallery owners and directors are present at the fairs, but it is difficult for them to respond to your questions because

collectors are hovering around their booths. However, you will have other opportunities. At the biggest fair, Art Basel, which now travels and has an event in Miami as well, you can certainly meet people. All around the fair are some of the wealthiest collectors in the world. The place to meet them is not near the booths themselves, where business takes place, but in the lounges and bars. If you are this adventurous, you will have to buy a pass to get into the fair, or know someone who has one. You will also have to be brave enough to not hesitate to ask someone wearing a power suit what their name is. If you do not have a pass to the fair, you may also be able to meet people in bars and hotels around the fairgrounds. These can be very high-powered encounters, but if you meet people and get their business cards, that in itself is a victory. Be forewarned that there will be a lot of schmoozing going on at these scenes, and if you are not up for that, I wouldn't go, because that is how the game is played there.

Minor but Important Fairs

Many other art fairs are different, where people can be much more approachable and relaxed. When big fairs like Basel in Miami or the Armory in New York come to town, there are several small fairs that are usually nearby to take advantage of the huge art-loving crowds that gather. It began with a fair called Scope, originally organized by a director of a gallery, and then others began to pop up. Now there are also artist-run fairs like Pool, which take a funkier approach to fairs, nearby these big events and take place inside hotels. After paying a participation fee and the cost of a hotel room, each artist or gallery representative takes a normal hotel room, turns it into a gallery setting, and remains there to talk with other artists and prospective buyers. This arrangement works nicely, because the artists will also have a place to sleep that night.

Artist-Run Fairs

The artist-run fairs can be a lot of fun because there are other events taking place besides the activities inside and around each booth. There are usually performances and parties and an overall social-party atmosphere, because people are there especially to meet each other and make friends, and they are all artists. If you have been saying that you want more friends in the arts, then artist-run fairs are one place you can make them. The central purpose of these fairs is building relationships with new people rather than solely trying to make sales. The gallery representatives want to meet collectors, and collectors want to be introduced to new artists, and the artists want to find buyers who are as passionate about their work and artistic vision as they are.

> When making relationships and friendships at these fairs, keep a few things in mind. Collectors will generally be the easiest to talk to because they want to know and understand more about art and artists.

The Collector

Everyone wants something from the other art fair participants, but the collector has a rather unique position that the dealers and artists do not. While dealers and artists worry about selling as many pieces as possible, collectors can focus on having a good time and seeing what is new and exciting in the art world. If you are a top-level dealer at Basel, you have less pressure in some ways, but more in others. You may not have to prove yourself as much, but you have to be efficient with your time and meet new collectors as well as museum directors and critics who can significantly influence the value of art.

As an artist with a booth or a room, you feel you must at least make enough sales to cover the cost of the space you have rented to show your work, so there is some pressure. But collectors, as I said, feel less pressure, though at the highest levels, they are competitive with each other and want to own the trendiest and hottest works of art.

Relationships at Fairs

When making relationships and friendships at these fairs, keep a few things in mind. Collectors will generally be the easiest to talk to because they want to know and understand more about art and artists. The other thing to remember is that you are there to meet people and exchange contact information with them. If you have a room at a fair, be sure to have a guestbook where visitors can leave their emails. If you are just walking around

the fair looking to meet people, always ask for a card. If they do not have a card, ask them if they would like to keep in touch, and take down their email however you can. I think the easiest way is to send a text message to yourself, that's what I do.

Keeping Track of New Relationships

If I am talking to someone who is interesting or well connected, I tell them I would like to keep in touch and ask for their email, which I then text to myself. You could write the email on paper, of course, but by using your phone the information is archived and you're less likely to lose your phone than a business card or scrap of paper. I have collected business cards over the years, but unless I enter them into a digital database like an email address book or an email-marketing program, the information gets lost or becomes impossible to read. The reason preserving email addresses is so important is because you want to develop your new relationships so that in the future they might bear the fruit of art sales and new exhibition opportunities. Everyone you meet at these fairs can be helpful to you in the future, so this is a chance to promote yourself and advance your career in a big way, just by making new friends.

Parties are Good, in Moderation

By all means, you should go to and enjoy the parties at these fairs, but be careful not to end up talking to people all the time. It is easy to just hang out with fellow artists and get their email addresses, but you also need to be trying to meet the collectors. Talking with collectors is hard for most artists. Probably you are not used to talking to collectors (or other

> If you are running your own booth, be friendly when people come in and try to start conversations—you will be more likely to make sales this way.

very wealthy people, for that matter); and so you are leaving your comfort zone.

Who wouldn't naturally be reluctant to jump into this situation? But since you are at the fair to meet people who can help you, you have to help yourself by expanding your social circle.

Sales

Let's assume you have decided to join one of the artist-run fairs to show your work in your own booth (or hotel room). To save on the cost, one option is to split the room with another artist, ideally one you would be comfortable sleeping with so you can share the bed too, but that is up to you. The gamble you take in investing in a booth or hotel room (especially for artists who do not have strong sales records) is that if you don't make enough sales, you are losing money. Many artists who have booths never worry about sales and instead hang out in their rooms, serving wine or juice and hoping that their art on display will catch the eye of passing buyers.

Sometimes this works, and people do make sales, but this is the exception and not the rule. If you are running your own booth, be friendly when people come in and try to start conversations—you will be more likely to make sales this way. Also, if you have a friend who is an actor or a salesperson, you could ask them to help you in return for a commission on the art they sell or a flat rate that you agree upon in advance. The money you give that person will be well spent, because if they generate more sales than you are able to make on your own, you are in the black. Of course, it helps to have your booth be easily

noticeable from the outside. The next step is to think about how you can promote your booth to increase foot traffic.

Promoting Your Booth

To promote your booth or room, you can employ traditional as well as nontraditional tactics. Traditional tactics mean advertising, which can range from using your Facebook page to tell friends, to local print and web advertising. If you don't have a budget for promotion, you can think about performances or other guerilla tactics. If you are sharing the booth with a friend, one of you can go out and promote in person while the other remains inside. Handing out postcards is a good method, but make sure they have an eye-catching design or promotional hook. Have a picture on the front, and invite them to an after party on the back. People will be more likely to come if there is a social element to the event. Try to think of other gimmicks, such as free giveaways to the first 10 people who visit, or adding a performance by a band or well-known artist.

Do a Performance or Hire Someone

Another way to draw a crowd is to have a performer put on a demonstration outside your booth. You know how stores sometimes have people dressed up in silly costumes to draw attention? That can work for you too, but since you are an artist, the performance should be more interesting. Most art fairs have a good amount of traffic anyway, but this is not always the case. I have seen artists invest a lot of money into a booth only to find out that the organizers didn't promote the fair enough, and by then it is too late. So if you are in a fair that is run by artists, it is wise to find past participants and ask

The artist TMNK makes his living selling his art on the streets of New York, and for a few years, he sold his art on eBay as well.

them what they think about the fair in question.

Brand New Fairs

Some independent fairs are run better than others of the same size, and they change from year to year, so be sure to learn a little about their histories by searching on the web and finding people who have been associated with the fairs in the past but are no longer running them. Most fairs have lists of participating artists online, and you can easily write to the artists and ask what their experience at the fairs were. The easiest way to get their email addresses is to look up their art website or Facebook page. I have found that Facebook is the easiest way to contact people you do not know, because unlike regular email, their inboxes are not filled with junk or spam.

Do-It-Yourself Fair

The DIY fair is another approach that can work out well. Essentially a DIY fair is when there is a big art fair near you like Basel Miami Beach, and you rent a space and host your own show. Graffiti artists, among others, have done this very successfully. If you do something interesting and promote your space well and have good art on display, you will be easily noticed, because you will be outside of the main fair area and will be viewed as an independent artist, and thus will be more likely to get better press and reviews.

How TMNK Did It

The artist TMNK makes his living selling his art on the streets of New York, and for a few years, he sold his art on eBay

as well. He talks to students in high schools and likes to say, "I am nobody, and if I can do it, then anyone can." What is different about him is his relentless pursuit, as he says, for what he wants. And one of the things he wanted was to go to Basel in Miami Beach and find a way to show his work. He told me he was thinking of renting a carwash for the day. As he calculated, a carwash couldn't make more than $1,500 a day, and he was willing to pay that much so he could use the space to exhibit his work. But he never did that because, according to him, once he was in Miami he went around the city and found a better place.

Getting a Space

Eventually he met a developer who rented him a space in the heart of the fair district, right across from a permanent collection of a wealthy family that received an exceptionally high amount of traffic on its own. TMNK was not the first person to have success by renting a space around the fairgrounds, and in fact this method has since become more popular among artists and may be a viable option for you as well.

Once you have your own space, you can host parties, openings, and band performances, and you will have a lot more room to experiment with new ideas. In the end, renting a space could (though not necessarily) be cheaper because you will be in control of all the decisions that must be made, but you must do what TMNK did before renting his space— go to the fairgrounds and start checking the neighborhoods for empty storefronts or warehouses. Who knows what you will find? Depending on your art, you may be able to use an outdoor location as well. After finding a suitable location, your next task is to find the realtor who is in control of it.

Realtors, Owners, and Developers

There won't always be a realtor, and in those cases you will
have to negotiate a price with the land owner or developer.
If you are talking with an owner, the process will be similar
to negotiating with a realtor. Tell them who you are and that
you want to exhibit your art in their space and chances are
they will be willing to work with you for two reasons. The first
reason is that to hang art on the walls and leave the rest of the
space untouched is not likely to cause any significant damage
to the property—and you can sweeten your offer by agreeing
to coat the walls in white paint. The second reason is that the
people who will be coming to view your art will mostly be
middle-class art lovers who are not likely to cause trouble

and are also potential clients for the realtor. These will be your selling points for both private owners and the realtors. The upside for

> *If renting a space nearby a major art fair is something you want to try, just begin to look for spaces and be prepared to negotiate.*

the realtor is that you are drawing attention to their space, cleaning it up, and increasing the likelihood of someone else being interested in renting it. There is nothing like an empty room with art on the walls to inspire others to think about what they could do with that space.

Your Budget

The final and most important thing to consider is how much that space will cost. You don't want to go over budget, so first decide how much you can spend on rent, paint, and other installation costs like electricity. Let's say your budget is $1,200, and you cannot spend more than that. If that is your amount then the rent should be no more than about $800 for the three or four days of the fair, but remember that you will need to acquire the space sooner so you can clean it up if necessary, paint the walls, and hang your art. It's important to have a rough budget already in mind when talking to the person who controls the space. Have you already figured out how much the paint and other installation materials will cost? It is OK if you don't have the exact figures, but be approximate, and err on the side of over-budgeting. That way, when you talk to the person in charge of the space you will be organized and will know right away if you can afford the space or not. Keep in mind that as an artist, the person you are talking to knows that you are not rich, and

that you are ambitiously fronting your own money to follow your passion. This may motivate the realtor to go easier on you during the price negotiation. It also means that if you are firm about the costs and your budget, the realtor will believe that they cannot demand any more money if they want your business. You may also offer a piece of your art to sweeten the deal. Most people like the idea of being a collector, especially if the art in question is associated with the major art fairs nearby. If renting a space nearby a major art fair is something you want to try, just begin to look for spaces and be prepared to negotiate.

Chapter 8

Public Art and
Independent Projects

Many artists do not feel that their work is suitable to become public art, or have never ever considered the possibility that it might be suitable. It is, however, an area where any artist can make a proposal, and it is one of the least competitive areas as well. To begin, let's define what public art means.

What Is Public Art?

The definition of "public art" has changed dramatically over the past ten years. It used to refer to sculptures or murals that were displayed in public. Traditionally, the way artists got these types of commissions was by registering with a local council on the arts, or if they lived in a country outside the U.S., with a local government arts center. After completing the registration

and application process they would be considered for future public commissions. This is still one way to be commissioned for public work. Each state has a council on the arts, and they can tell you how to become eligible for new projects. In most cases, you will have to send images and a resume to the agency that your local council on the arts directs you to.

Percent for Arts in the United States

There is federal money controlled by the state as a tax on new construction. The way it works is through "percent for arts," which means that for every public building created in the United States, one percent of the total building cost must be set aside for the purchase of art. That can be a significant sum, because if a building cost two million dollars to build, there will be a $200,000 budget for artwork. Usually that budget includes the artist's fee and material costs. Keep in mind that creating a work of art that can withstand all forms of weather can get quite costly. I will discuss how to create winning proposals for this traditional type of public art later in this chapter, but first I want to explore other forms of public art.

Government Agencies/Nonprofit Institutions

Working with local government agencies is still a good path for making public art, but the players have changed. There is a non-profit art group in New York City called Creative Time, and they have been at the forefront of commissioning new and innovative public art. Their goal (shared by many other agencies like them) is to find out new and exciting ways to engage the public with art. The first project I saw by Creative Time was done in Times Square in NYC where dozens of giant video walls flash ads and

videos of various com-
panies. Creative Time
made a deal with one of
the owners of the video
walls that allotted the
first minute of each hour

One of the most recent new public art forms is represented in a project called FEAST, which started in a few different communities and has been replicated in many places thereafter.

for an artist's use. That meant twenty four times a day an artist's video played on these screens. Great idea isn't it? That section of New York City is a huge tourist attraction, and the likelihood of the artist's work being seen was great. And even if the viewers don't recognize an artist's work at first sight, the work will likely be different from all the ads around it, creating curiosity and intrigue. Billboards have been used in the same manner, with art agencies and artists renting space to showcase their work. There are other types of nontraditional public art, but these are just a few examples.

Collaborative Exhibits and Fundraising

One of the most recent new public art forms is represented in a project called FEAST, which started in a few different communities and has been replicated in many places thereafter. A dinner is held and four to five artists and at least a dozen non-artists are invited to attend. Ideally, the event space is at a public space that can be loaned for free, such as the basement of a local church (which is where one FEAST event was done) or a school or even an office building.

How FEAST Is Run

The first dinner would work in the following way: The dinner space must be able to accommodate an art exhibition with

enough space on the walls for the artists to hang their work. You tell the artists you invite to give a proposal during the dinner on what they want to hang in the space and why their work would make a good show. They can bring images or the actual art pieces if they are not too difficult to transport. When you invite the diners, explain that artists will be giving presentations during dinner and the diners will be asked to fill out a form and vote for the presentation they like best. Also explain that there will be a minimum donation of ten dollars to cover the cost of dinner.

Voting for Artists

During dinner, the artists will stand up and give their presentations one at a time, doing their best to demonstrate what their exhibits will look like and persuade the diners to vote for their ideas. When dinner is over, and before dessert is served, the votes will be tallied and the winning artist announced. The winner will receive all the donation money collected earlier (no less than one hundred dollars) and the rights to install their art in the room for the next FEAST event, which will take place a month later. Ideally, the diners who voted for the winning artist will attend this second event so that they can see the art they voted for in full scale.

The Next Month

The second FEAST event will proceed just like the first. Four or five artists will give short presentations, the diners will vote, and the winning artist will be awarded the money. This is a new and exciting form of public art, because the public (the diners) are involved in choosing the commissioned art and will get more satisfaction out of seeing it displayed. The

first event is the hardest to set up because you have to find a space and make all the preparations, but you

For a FEAST, the first step is to find a place where you can stage a dinner and exhibit artwork.

will find that most people are excited by the idea and want to participate, and why wouldn't they?

Expenses

One of the biggest expenses for this event is the dinner itself. To help offset the expense, you can ask local restaurants and caterers to donate food. They will probably be willing to help, considering that this is a community event, especially if you tell them that donors will be credited on event press releases which you will be posting in local newspapers and on the menus that you will provide your dinner participants. Events like this, where the production costs are small or nonexistent, are called "sustainable funding for artists," because, in many ways, that is exactly what this is. If the idea excites you, you should start planning your own event right away. Look up FEAST art online and you will see more material about how many people have done it.

First Step: Find a Venue

The first step is to find a place where you can stage a dinner and exhibit artwork. A church basement can be perfect, but it could also be in someone's home, an office, a car dealership— almost anywhere that has enough vacant space and bare walls to hang art. Just be brave and start somewhere. Explain to a library what you'd like to do and emphasize that it will not only be fun, but will get the community more involved in

art and culture. It's OK if your sales pitch isn't perfect; it will get better the more you give it. The first step is to go out and give it your best and be positive. I think you will be pleasantly surprised how many people share your enthusiasm.

Second Step: Find Artists

The second step is to figure out which artists to invite. You must consider whether their style and medium will work well in the space you have found. You need about four or five artists, and it's OK if they are your friends. Otherwise, you can post an ad in the artist community on Craigslist and ask artists to send you links to samples they might use in their proposals. If you like their work and think they could make a good proposal, explain to them how the event will work and ask if they will participate. Most will be happy to join with the chance of getting to display their work and winning a cash prize. The only thing left to do is get a couple of friends to help you make dinner.

Third Step: Dinner

You can either make something inexpensive like a big soup with bread, or you can ask local restaurants and caterers if they will help. Don't forget to tell them you will be sending out press releases that mention and thank your donors. The likelihood of a great event like this getting press is very high, and it will be good advertising for the restaurants who participate. Once your dinner plans are finalized it's time to invite your diners. Who refuses an invitation to dine with other art lovers? Explain in your invitation how the event will work and let them know that a minimum ten dollar donation which

will become the winning artist's prize money will be required at the door.

Last Step: Enjoy Dinner

Your last step is to make the dinner and have fun. Once the presentations are over and the votes are counted you will have the pleasure of presenting the winning artist with the evening's proceeds. You can probably see how this will grow after it's initial success. Word will spread and more artists, press, and hungry art lovers will want to get involved. One of the exciting aspects is that the diners who come once will have an incentive to come the next time – to see the art that they voted on at their first dinner!

Community and Public Art

For the diners, there is something very satisfying about being a patron so closely involved in the local art community. From the artist's point of view, what could be better than being paid to put on a show? Personally, I love this model, because it can be done almost anywhere in the world. You don't need to be in a big city, you just need a dozen or so artists and a community of people who like to eat.

New Forms

The FEAST event is nice because instead of filling out lengthy applications and proposals, all an artist has to do to show their art in public and give a short presentation. Even more unusual, they will know the results that same evening. The experience will also let artists practice their verbal pitch skills which will help them give better proposals in the future.

Public Proposals

Another type of public art is when you negotiate terms that will allow you to display your art in a public space. The artist Christo, for example, gives proposals complete with drawings and models to city officials or building owners. He is able to fund his projects by selling his artwork. So, if Christo wants to wrap a building with his signature cloth so it almost looks as though it is under construction, he will begin by sketching the project and then he will approach the building owners directly and present his idea. The owners do not give their approval because Christo is rich or famous; they do so because he is ambitious, has a well thought out plan, and the spunk to ask. Artists may have heard of Christo, but most

people have not. The point is you do not need fame to land a large scale project like this, you only need a good idea and some confidence.

Here is an example of an artist who used Christo's approach to make her own temporary public art.

A Sculptor Takes the Town

Here is an example of an artist who used Christo's approach to make her own temporary public art. Part of my profession is coaching and mentoring other artists, and this is the story of one of my clients. She came to me wanting to jump start her art career. In the past she made sculptures that looked like very large flexible tubes, the kind that might be used for a huge air conditioning system, and had done temporary exhibits for competitions where she weaved the tubes through the windows of abandoned apartment buildings. She showed me several images.

The Model, DIY

The pictures looked wonderful and her art had a refreshing sense of humor about them. They were also strange and looked very odd in a way that attracted attention—like all good public art should. I explained to her that she could follow Christo's example rather than try to get a gallery to support her or waiting for a local art agency to award her an opportunity. At first she hesitated. "You mean just go out and do it myself?" "Yes," I replied, and that is what she did. I didn't work with her for very long because she grasped the idea right away, and with minimal support from me, began sketching her ideas, found a way to present them, and sent out press releases. She then made her tubes and put them through the windows of parked cars in

Online projects ideas are another form of public art. Even museums are starting to collect Internet art.

various neighborhoods. She didn't even need to ask permission.

Success as an Independent Artist

She took photos of her car art and sent them out with press releases. The result was a full-page image in *Time Out* magazine in New York and an interview on national television. She realized once she had a clear picture of what she wanted to do, executing the plan was fairly easy. She was not famous or rich, she just had a creative idea and went for it. She got what most artists dream about—national press and public exhibits—and with the right attitude, you are capable of achieving this level of success as well. It does require that you write a press release and send it out, but you can do that easily yourself or get help from a writer friend if it seems beyond your skill level. For her, and perhaps for you also, the experience changed her perception of how she could go about exhibiting her work. The Christo model provided the "aha" moment she needed to take the reins of her career in her hands and control her destiny. Now she no longer has to wait for a break or an application to be accepted.

Internet Art and the Web

Online projects ideas are another form of public art. Even museums are starting to collect Internet art. While broad in category, anything that the public can view can be considered public art, even your personal website, though in my view, in order for an Internet project to be art, there needs

to be something more to it. The first examples I saw of Internet art in the late 1990s were almost like games, where the cursor would roll over hidden links to other areas or reveal words that were hard to make sense of. The objective of this kind of art was to find out what the Internet mechanics really were and to try and use them to create an interactive, aesthetic experience. Since then, it has vastly evolved and artists are using the Internet to create a variety of new projects.

Taking On Corporate Culture

One fairly radical project was done by a group of artists called the Yes Men. Their artistic goal is to make fun of corporate culture, and in this particular instance, they did so by posing as corporate CEOs. They made websites that duplicated an actual company's website (and had similar domain names), Exxon, for example, complete with links to parts of the real Exxon website. But the big difference was that they included what looked like email links to the CEOs on their home page, but the links were actually attached to the artists' personal accounts. Then, they waited for email requests for the CEOs to give presentations at a conference.

Performing

The Yes Men would accept the invitations, and give presentations to very prestigious groups of people because they thought they were hiring major CEOs. The Yes Men tend to be critical of corporate culture. At one event, they presented a gold skeleton and discussed the value of a human life. They said that some skeletons—that is, some lives—are

worth more than others and can be calculated precisely when making corporate decisions. They mentioned the Bhopal disaster in India that killed thousands of innocent people and explained how those lives were not as valuable as lives in other parts of the world.

Documents and Reaction

The Yes Men videotaped all of their presentations. The remarkable thing when watching the footage is that often times the audience liked what they heard and agreed with what the Yes Men said. The film they made about their work is a horrifying indictment of corporate culture, and it is available to rent online if you are interested in seeing it. The Yes Men are a great example of how to effectively use the Internet for artistic purposes—in their case, to create art that criticizes corporate culture. In my opinion, their approach of starting something that begins as a hoax and ends in critique is a fairly sophisticated use of the Internet, but there are many other ways to utilize it.

Do You Have an Opinion?

Do you have a message you want to relay to the world? The Internet reaches a vast, and in many ways, gullible audience. Be careful how you proceed if you decide to try something similar to what the Yes Men did, for even they are susceptible to legal repercussions. A tamer version of what they do would be to create a collaborative, interactive space where people can make art together, or make a website that does not show your art, but creates a guessing game of some kind.

Hell.com and Internet Art

One of the most fascinating and enigmatic pieces of on-line or "net-art" is a website called hell.com, a coveted domain that gets thousands of hits every day from people

The hell.com designers always seemed to have a sense of humor even if it was hard to follow. They defy our expectations of what it means to navigate the web by making their site function the opposite of what we expect.

who type hell.com in their browser for the sake of entertainment. It remains a curious place for art and utilizes some of the most sophisticated uses of web design. For a while, it was very difficult to navigate, and there were obstacles like hidden pass codes which, if you did incorrectly, would reroute you to a random Internet search. It was frustrating, but sometimes beautiful. Every time I checked the site, there were always different things happening.

Nosuch.com

Once, when I went to the site, it automatically sent me to another domain called nosuch.com. The hell.com designers always seemed to have a sense of humor even if it was hard to follow. They defy our expectations of what it means to navigate the web by making their site function the opposite of what we expect. While writing this book, I went to hell.com and found a completely blank page. At first I thought something was wrong with my browser, but I could see that the site had fully loaded and there had been no error. Then I noticed a message at the top of the browser, which said "domain disabled"—a message I have never seen before. Hell.com has a reputation for using the Internet in unique ways that tend to confound their viewers, and one of the definitions of art is to challenge the norm and

make us think. Hell.com has certainly done this. You can read more about this notorious and odd work of Internet art on Wikipedia. Perhaps it will inspire you. You can also listen to the full interview I did of the founder of hell.com on Yale Radio, (wybc.com) under The Art World Demystified public affairs program.

Interactive Work

Other new forms of public art include "interactive" works of art which have become increasingly popular. My wife and I began giving foot washings and hugs to the public through a storefront we rented in the East 10th Street in New York City. That was, believe it or not, considered public art, and was included in the Whitney Biennial in New York. More and more nonprofit organizations and galleries are promoting performances as public art forms.

Performances as Public Art

I remember a piece where a woman was selected to create a work of public art for a plaza that would last for three weeks. In the plaza, she built a house the size of a small shed with a window and a ledge on which she could cool pies. On certain days of the week, she would bake pies and leave them out on the ledge. She wanted people to take them, to steal them, and that's exactly what happened. It was like making a fairytale come to life. I used to go through a corporate lobby on a regular basis, and there were always new artworks on display. While some fit traditional mediums of sculpture or painting, there were interactive pieces as well. One that I liked was a row of very large wide-mouth bottles that contained soap bars in them, each embossed with a

word like "greed" or "love." The public was invited to take one, and it made me smile to see all the jars almost empty every day.

Have a picture of what the finished piece would look like in the space you want, and have a rough idea of the budget needed to create and install it.

Dance, Sculpture, and More

Interactive public art like the examples above keep growing and diversifying, and the term now includes dance performances and sculptures that you can interact with or climb on. But because works like this are hard to sell, they are often self-funded or funded by grant money. Still, they are a good way to get public recognition.

Permanent Sculpture

Permanent, public art such as sculptures can still be created and sold, of course. College campuses, for example, often have monuments. If your college alma mater allows public art, you can go directly to them and ask to speak with the person in charge of acquiring public sculpture. This is often not as hard as it may seem. It just takes a call to set up a meeting with the right people, and then you can propose a site on campus and how you'd like to use the space. You can sometimes get your work purchased by being that direct. I have worked with artists who are very successful placing their art on college campuses, so if you are a sculptor or a painter with a mural idea, do not hesitate to take action. But be as detailed as possible. Have a picture of what the finished piece would look like in the space you want, and have a rough idea of the budget needed to create and install it.

A Good Proposal

At the beginning of this chapter we talked about traditional methods to get public art commissions by applying through local agencies for new construction projects. Remember to inquire at your local council on the arts about this, or if you are in a country that doesn't have a council on the arts, inquire at the local art center. Now, I want to talk about how to make a good proposal.

Competitions

Sometimes when there are competitions for public art proposals, there is more than one round of discussion. At the first meeting you will be asked to describe your idea, and you need to be as precise as possible, and have compelling, detailed images ready in case they want to see them. Remember that the architects and city planners evaluating your work want to know three things: 1) Is your work attractive and fitting for the environment? 2) Is the proposal clear and understandable? and 3) Can you execute your project well? These are the questions you must answer convincingly. For question one, of course your art is good, but more importantly, it has to look good in the location it will be placed. It is helpful if you can place your art on a photograph of the site (imagine the way architects propose their buildings).

Rendering / Modeling Is Everything

Architects make cute scale models of their buildings and the surrounding buildings, complete with scale people, cars and trees. They also make composite images with people and street

traffic which give a sense of what their finished product will look like. The closer you can come to that with your project, the better, because they will be able to visualize your project. If you can't do that easily yourself, find someone who knows how to use Photoshop and ask for help. A beautiful image will make a huge difference. And as with an architect's proposal, your writing should be clear and to the point. By clear, I mean that you should not talk too much about the work's meaning, but focus instead on how it will affect the people that see it, and how it will complement its surroundings. The last thing to remember is that you must convince them that you can do it. If you have never done this kind of work before, you have two choices: Either include a partner who has public work on their resume, or be very detailed. By detailed, I mean show exactly how you will paint the mural and discuss the equipment and materials you will require and how you will obtain them, etc. The more you can demonstrate that you have thoroughly covered the logistics of your project, the better. If you expertly cover these three questions, the more likely you will be to get the commission.

More Options

If you choose to proceed with public art, you should be aware that more and more artists are redefining what it means to work in the public, and you, too, can help create new ways to reach your audience. Look at how many people are using platforms like kickstarter.com to raise money for public art projects. I explain about new platforms and kickstarter.com in detail in chapter 14.

Chapter 9

Art Consultants and the Digital Gallery

Art consultants may mean different things to different people. For collectors, art consultants are people who help them shop for art. They know the art market well and can help to build a good collection. Consultants do not work with artists directly, but buy art through the galleries they have relationships with, or at major auctions. Their primary goal is to build collections that have value as short or long term investments. They work for private collectors and buy from galleries, auctions and fairs.

Consultant as Dealer

The other type of art consultant is one you can work with directly, who sells work to clients that range from homeowners to hospitals, corporations and hotels. Some consultants specialize in a specific area. There is also an overlap with

interior designers. Some designers find their own artwork, while others look to interior art consultants for a selection of possible work.

Hotels and the Private Sector

For the purposes of this book, we are focusing on consultants who sell to corporations, hotels, and the private sector. Depending on how much of an entrepreneur you are, you can either work with art consultants to develop an income stream, or you can become one yourself and sell the works of other artists. I mention this option because once you get the idea of how to work this particular field and establish connections, you could do business with several artists with little extra effort, because you are contacting the same people you've already started relationships with.

What You Need to Begin

To become an art consultant you need three things: Your images must be online so they can be easily seen, you need professional contacts,

When you are searching for consultants, look at their websites first so you can determine if they sell other artists' work to other institutions. This is the kind of consultant you want.

and you should have prices ready for prints. Most important are the contact information of the art consultants you want to work with. I would suggest you begin by searching Google for the art consultants in your area. There are several in major cities, but you can also find them scattered across the United States and the rest of the world. I regularly publish an updated list of art consultants on my newsletter which is available through my website, yourartmentor.com.

Reputable Consultants

When you are searching for consultants, look at their websites first so you can determine if they sell other artists' work to other institutions—this is the kind of consultant you want. You don't want consultants looking for private clients to build art collections. Take your time and build a good list. Once you have fifty names you are ready to begin.

How to Contact Consultants

You can start by sending them a brief, professional email. Do not attach images to your messages because mail programs might automatically flag your email as junk mail, and some people are hesitant to open large attachments from unknown senders because of computer viruses. When I receive image

attachments they are usually so large that in order to see them in their entirety I have to download them to my desktop and open them up again. This is an inconvenience that can be easily avoided by simply providing a link to your images in the body of your email, rather than sending attachments.

Make a Simple Link

The link should direct them to a page where all your images are neatly displayed. Be sure not to send a link that goes to a home page that requires additional clicks to get to your images. Even if you are not a web page designer, there are several easy ways to send direct links. If you have a Gmail account, you can also log in and use Picasa, which is a photo sharing site like Flickr that is run by Google. Photo sharing sites allow you to upload and share your images very easily. Once you upload images to Picasa or Flickr, you can then send a link to a particular group of images or an album of photographs.

Organize Your Images

You can also create multiple albums to show different groupings of work. You can also share your images by uploading them to Facebook and sending your recipient a link which allows them to see the images as long as they have Facebook themselves.

My personal favorite is Picasa, because it offers great flexibility with how you share and organize your photos and send links.

Navigation Must Be One-Click

However you do it, getting your images online is important, and it must be done in a fast, simple way. A one-click link to

all of your images is the best option. Remember also that the picture quality must be good because the clearer the image, the easier it is for the

> You need to talk to a printer, because you need to know how much you have to sell a print for in order to make money.

consultant to evaluate your artwork, and, some consultants will actually print the images you send them. This is the new realm of on-demand printing which you will be getting into here.

Digital Publishing

All consultants will have slightly different ways of working with artwork, but there is a growing popularity in digital files that can be easily printed. Here's how it works: A client receives an image or a link to an image from the art consultant, and if the client likes it, the consultant can print it out in whatever size the client wants. That means they need a high quality image from the start. Many print on demand sites will tell you exactly what they need in terms of image size and quality, but another way to find out is to go to your local printer and ask if they print on demand. If they don't, find one that does and is close enough that you can go to them if needed.

Printers

The reason you need to talk to a printer is because you need to know how much you have to sell a print for in order to make money. Assume the consultant will take fifty percent of your retail price. To determine the price of your work, factor in printing and domestic shipping costs plus the half of the total that will be going to a consultant. When asked how much a

print is, you should know the answer offhand and the profit margin you stand to make from that sale.

Follow Up

Follow up is very important, which is another reason why you don't want to contact people you haven't researched. After emailing everyone on your list, you should send follow up emails every two weeks to reiterate the sentiments of your first email, and, if applicable, let them know that you have a new image to show them. You are building relationships with people who like to see that you are serious and professional about your work. They want to see that you are a consistent and reliable business partner. Oftentimes, consultants are going from project to project, one week at a hospital or a corporate lobby, another week at a hotel, and by maintaining regular correspondence, you will sometimes catch them in the middle of a project your work is suited for.

New Images, Constant Communication

It is also helpful to call your list of art consutants once a month to say that you have been sending them emails of your portfolio, and want to know if the consultant is looking for any particular kind of art at the moment. Getting to know the consultant and their preferences is key because that personal connection will make you and your work stand out that much more when the consultant begins selecting work for new projects.

As you foster these relationships you will find that you get more sales, and that momentum can steadily grow. It's time to created another list of fifty consultants and repeat the process. Before long, you will have a dozen or more contacts buying art

from you on a regular basis, providing you a steady stream of income. Once you have reached this plateau, you can consider consulting for other artists.

Becoming a Consultant Yourself

Since you now have the contacts and understand the system, you also have friends in your artist network, and they may be interested in selling prints. Barbara Markoff wrote a book that is an excellent resource on how to be an art consultant and run your own business. It is easier than you think once you establish yourself. As a last word on dealing with art consultants, if you are asked to pay to be represented, do not do it. No consultant should ask for money up front. If they do, refuse to work with them. Keep in mind, you are an entrepreneur starting a small business, and you need to use your head and make smart business decisions.

The Daily Grind: Managing Time and the Dream of Art

As you use this book to supple-
ment your personal strategies and advance your career, you
may find that it is difficult to efficiently manage your time.
As you develop new markets and further develop ones that
already exist, you run into the problem that all entrepreneurs
run into—how to get more time out of your already full day. In
this chapter, I will present some techniques that can help you
manage your time so that you feel good about what you have
accomplished by the end of each day.

Daily Calendar

Using a daily calendar is a good place to start. In the age of
smart phones and computers, online calendars have several

advantages. I use Google Calendar as well as iCal, which is the calendar application that comes pre-installed on Mac computers. If you have a Mac and an iPhone, you might also consider using the Apple service Mobileme, or the latest version of it, which allows you to easily sync up all of your contacts so that if you type an event or contact into your calendar from your computer, it automatically goes into your phone as well, and vice versa.

Online Calendar-Sync Services

The Mobileme service is $99 per year as of this writing, but the Google equivalent is free. With Google Calendar, one of the many features that come with a Gmail account, you can also sync events and contacts to your mobile device. What I find handy about Google Calendar is that I can also sync my daily work schedule and events with other computers, so if my wife has Google Calendar on her computer, I can access and update my information there as well so she sees it when I enter in a new meeting. This versatility makes planning and changing schedules on the go much easier. If I am out at a meeting and someone asks when we can set up another meeting, I can use my phone calendar to pick a time that works with my schedule. That's why I strongly suggest using a calendar system like this of some kind to keep times and tasks organized.

Using Other Calendars

You can even import other peoples' calendars into yours, which can be helpful in planning your own daily or weekly

activities. For example, I am currently writing this book in one of the libraries at Yale University. On the Yale website they list their oper-

> When I am at an art opening and I meet someone who invites me to their opening, I just enter it into my calendar, and I will never forget it.

ating hours and the days they are closed. I downloaded this information directly to my personal calendar, so now I always know when I can do my work at the library. And if I find that the new information looks too messy or confusing on top of my own, I can turn the library calendar off with a single click. And even though I have one calendar for work, I keep another calendar that I share with my wife, which includes more activities. In this home calendar, I list my son's special classes, and any of his upcoming events that I should attend. As I said earlier, all of these events sync up with my phone right away. When I am at an art opening and I meet someone who invites me to their opening, I just enter it into my calendar, and I will never forget it.

Making the System Work for You

That should be enough to convince you that an electronic calendar is far superior to a traditional paper calendar. Next, you must figure out how to make the system help you get more work done. First, set aside a time of day to work on a new project. If, for example, you are going to work on selling your art online the way Abbey Ryan did in chapter 5, you can start the process by devoting thirty minutes a day, four days a week to the effort. It is easy to mark the exact time in your calendar and stick to it.

Start with Only 30 Minutes Per Day on Business

The reason you are choosing only 30 minutes a day for four days a week instead of five is because your likelihood to succeed is better if you start with a short, realistic time frame. I am a morning person, so I would begin around eight or eight-thirty. Input the date and time in your calendar and set it to repeat every week. Now, you are committed to adhering to this schedule for a predetermined period of time.

Let's say it is the first day of your new schedule and you have decided to do a painting and post it on eBay. In that thirty minutes you have set aside, you can do anything except paint. You are taking time to address business aspects, which might be the most difficult or least exciting parts, but doing so will make you feel good about what you've accomplished as you move on to the artistic matters. If you fail to do this, you risk feeling as though you have not done enough. And though a half hour may not seem like much time, it does add up if

you do it every day. Because you do not have to do all of your task today, just spend 30 minutes working on it, which might mean just look-

There will be days you don't feel like doing your thirty minutes of networking online. On those days it is important to do it anyway.

ing at eBay and what other artists have done for one session, your first perhaps.

Your First Day

So, it is your first day on this schedule, what do you do? You can begin by doing a little research on artists like Abbey Ryan or TMNK (The Me Nobody Knows) to see how they promote themselves. A good first step is beginning a blog on your current activities and projects. If you want to post art every day, you can declare your intentions to the world, and you can include a picture of yourself and your artwork. That might be enough for your first day, and on future days when you can't think of what to do, you can add another entry describing your process so far. You'll also want to open an eBay account if you don't have one already. When you look at the artists I mentioned who are selling on the web, you can see selling strategies you might want to use. TMNK and Abbey Ryan have very different approaches, and you might like one over another, or you may find your personality needs to be represented in a different way all together. But the daily grind of those thirty minutes must be adhered to for it to pay off.

Stick to a Schedule

There will be days you don't feel like doing your thirty minutes. On those days, it is important to do it anyway. Even if you get distracted and check your email instead of doing your

work, finish at the same time and do your best not to do unrelated tasks during that time period again. They don't call it the daily grind for nothing! Some days will be fun and inspiring, other days less so, but stay the course and you will see progress. This could be called time management, but really it is something else. It is managing your behavior, and even more, changing your behavior, which is one of the hardest things to do. But it can also be one of the most rewarding. We often feel trapped by our compulsions (smoking, procrastinating, etc.), but history has shown that we can overcome these powerful habits, and once we do, we will feel inspired in ways we never thought possible.

Consistency over Time

The trick is to stay consistent. When Abbey Ryan started selling her work online it took almost two years before she was making close to $100,000 a year. Can you wait that long, or perhaps longer? Sometimes life leads us to unexpected places. The last time I checked Ryan's page she was getting more and more publicity, and it looked like galleries were handling many of her sales now. That may have not been her original intention, but her persistence and hard work got her there. Another important daily task that will make the transition into your new life and new way of thinking easier is to create a statement of intent that you read to yourself daily.

Organizing Studio Visits, Parties, and Your Cult Following

Have you wondered how to manage a party at your studio and inspire the following that your art deserves? Methods for throwing events from sober and conservative to wild, memorable, and unrated, are all possibilities to build support for you and your art. The thing to keep in mind is that you are designing the party, and you are in control of the outcome to some extent, depending on your goals. Here are a few ways to get started, but remember, like other areas, this is wide open to inventive interpretations.

The Studio Visit

Ah, the heart of the art business—the studio. This is where deals are made, or where you meet someone who can make deals for

you. Artists have used studio visits to share and sell their work for years, however, there are new ways of getting people into your studio and networking with possible collectors. The studio visit is often misunderstood. It is not just a time to look at work, but a chance to meet the artist and learn who they are and what their process is. For the artist, I think the most important part of the studio visit is engaging visitors and hearing what they have to say. That might be the last thing on your list, but it is the first on mine; there is a lot to be gained from talking to your visitors. In this chapter, I will discuss several aspects of the studio visit, but I will start with the most intimate—the process of conversation and getting the visitor to talk.

Getting the Studio Visitor to Talk

One time my wife and I went to a small gallery showing Salvador Dalí prints. When I was a teenager, I liked Dalí quite a bit, so I was curious. We entered the rather small space and began looking at the eighteen-by-twenty-four-inch prints. The prints, lightly colored drawings with Dalí's signature line, quality and subtle references to himself and his work (the dripping clock, a crucifixion, etc), had large, gaudy gold frames around them. Though they looked like drawings, they were actually etchings from plates. As we walked through the show, whatever my childhood fondness for Dalí had been, was gone. The show was interesting, but not enough to keep me there for more than five minutes. I told my wife I wanted to go.

As We Were Leaving

Just then, a saleswoman, or perhaps the gallery director, asked me if I wanted a glass of wine or champagne. I declined,

but thanked her, and we started towards the door. Then, the woman called out and asked if she could ask me one question. I said yes, and she asked me which one was my favorite. She didn't ask if I had a favorite, or if I liked the show, she asked a direct question that required a straight answer—not a simple yes or no. So standing near the door, I answered her question by pointing to one of the pieces I liked better than the others. She smiled and said "Oh, that is a very special one. May I tell you something about it? It has a great story." Reluctantly, I said yes, and my wife and I were walking back into the gallery toward my favorite etching.

We Came Back

When we were standing in front of the etching, the gallery saleswoman began to talk. She told us that Dalí was describing his anger at the church, and as she pointed around the image she explained that this squiggle was Dalí, and that one was Gala, who would soon be his wife, and the symbol of the hat over there was the bishop. She said the etching was about how angry Dalí was with the bishop because he would not permit Gala and he to marry in the church since Dalí had already been married and divorced. She said this was a difficult time for Dalí because he loved Gala very much and wanted to marry her in the church. My wife liked that and we smiled at one another. Then, the woman told us that the etchings were part of a very limited series and that there were only a few left of this particular image.

Celebrity Name Dropping

Furthermore, she said that for those who bought from this series, there was a special cocktail party that the other collec-

> When a person comes to your studio they are potential customers. You can guess fairly quickly who does and doesn't have money to spend, but you'll be surprised sometimes.

tors would attend, one of whom was Mick Fleetwood. That caught my attention; I asked if that was the same Mick as the guitarist for the Rolling Stones? She said no, he was the drummer for Fleetwood Mac, and that he was a big collector of Dalí, and would probably be at the reception. She told us both a little more about the edition size and its rarity and then said that for $300, I could own it. I was shocked that it was so little, and she said that three hundred could be the down payment to secure it, and that we could work out whatever payment plan I wanted to pay for the rest.

Imagining Owning Art

Before I even asked what the total price was, I imagined drinking with Mick Fleetwood, who I imagined to be Mick Taylor, and having this huge gold framed print in my apartment. The woman had planted this fantasy in my mind. The print was several thousand dollars, and although I did not buy it, I was amazed at how close I came. The more I thought about it, the funnier it was to me, to own a giant Dalí print, but it was not out of the question. I really could have worked out a payment plan and bought it.

Your Sales Pitch

I tell that story to illustrate how a good, simple sales pitch can be extremely effective during a studio visit. When people come to your studio, they are potential customers. You can guess fairly quickly who does and doesn't have money to spend, but you'll be surprised sometimes.

The Soft but Enthusiastic Sell

When I owned a gallery, I once had an exhibit of a series of paintings on ironing boards by an artist that I liked very much. A friend of mine came to the gallery, and I started telling her how much I liked the paintings. We walked around, and I enthusiastically explained what the paintings meant to me and why each one was interesting, and to my astonishment, she said she wanted to buy one. I didn't think she had any money, but it turned out she had just inherited some from a family member.

Reading Your Potential Collector

When my wife and I were in the gallery with the Dalí prints, we looked like potential buyers even though we are not big collectors and would not normally (but could, in theory) buy art for several thousand dollars. The first rule of studio visits is never assume your visitors don't have money to spend. Simply try to get them interested in the artwork itself. All the woman at the Dalí gallery had to do to engage me was ask what my favorite print was. That one line got things going.

Questions to Ask

You should also brainstorm some good conversation starters that you can use to get your visitors personally involved in the exhibit. It is hard for anyone to talk about art, especially when they don't have many opportunities to in their daily life, but anyone can pick a favorite piece without having an artistic explanation for why they like it. If you do get someone to point out a piece they like, explain to them why it is special and talk

about what it means to you. Even if you don't have have a story or historical context about the piece, you can say something about how it was made or what influenced its creation. You want to teach them something about the work they are drawn to—and they want you to teach them. It also doesn't hurt to say that the piece they chose is your favorite also. Doing so helps create a stronger connection with your visitor.

Talking about Art

Art can touch people in ways they cannot describe, and often you cannot trace how or why a particular picture moves you. Therefore, if the studio visitor points to their favorite artwork, it is up to you to help them better understand it and increase their interest with a personal, meaningful touch. This is your goal during a studio visit. You want someone to walk away feeling like they now know more about themselves after

looking at your art; you want them thinking about the visit for the rest of the day. You might still be worrying that you do not know what to say about your art (whatever the medium), but consider more than just the work itself. The art can be a jumping off point to talk about something else. Let's say you have an abstract sculpture in your studio that vaguely resembles a tree branch or a human figure, but mostly looks like a twisted mess of clay.

Conversation Points

If that is the visitor's favorite piece, go over to it with them and tell them how much you love it too (and if you can think of the reasons you like it, mention those as well). How was it made? Does it remind you of something? You can talk about your inspiration and state of mind when you built it. But if none of these seem like viable options, then after you tell the viewer how beautiful it is, you can ask them if the sculpture looks like a particular shape or reminds them of something.

Get the Visitor Thinking

Be casual and reassure them that there are no wrong answers so they don't feel pressured. If they say it looks like car parts, then you can agree and explain how abstract work allows for more interpretations than one, which is why it can be so successful and subjective. And truly, like a Rorschach test, people do see different things in the same abstract work, and that is fascinating, because it reveals something about ourselves. Your visitor says the sculpture looks like car parts, but perhaps to you it is much more sensual than that.

Ask about What the Visitor Is Saying

Be curious and tell your visitor you agree with them. Sure, it could be car parts, but could it also be something else? If they don't answer, suggest other shapes and ideas that come to your mind. Your ideas may inspire the viewer to think of other things, but at some point you have to move the conversation to something that is a bit more personal.

Tell Stories

The story the woman at the gallery told about Dalí fighting for a loved one was powerful and easy to relate to. In the case of your sculpture, perhaps there is an art story you can tell even if it doesn't have to do with this piece in particular. Tell them how you began making art and what made you decide you wanted to work with sculptures. Perhaps there was a time when you had to argue with someone about why you wanted to be an artist, or maybe you had an internal struggle about being an artist that you resolved in your studio. Tell a story about something you struggled with—almost anything will do—and watch how your visitor reacts to what you say. Tell them the sculpture they are looking at is also about your struggle, and fight to do what you love.

Personal Topics

If you are comfortable enough, ask your visitor if they have ever had to fight for their dream. If they say no, ask if they ever had to fight for something they believed in. You will probably get a response, and when you do, recognize that this is a precious

moment. When people share personal stories they are opening themselves up to each other and strengthening the connection between them. Respond warmly and enthusi-

> When people share personal stories they are opening themselves up to each other and strengthening the connection between them.

astically to whatever someone tells you, join them in the triumphant feeling of talking about their interests and personal asides. Remember, the goal of having a studio visit is not to just make a sale, but to form meaningful relationships with people who want to see your art.

Making a Connection

Once you've connected with someone, that person will have a lasting and positive memory of visiting your studio, and they may choose to preserve this memory by purchasing your artwork. You don't have to talk about prices or sales on the first visit if you don't want to—you can do that on the second visit—but it wouldn't hurt to try. I would certainly not have gone back to the Dalí galley, so the woman there was smart to make her pitch while she could. If you are getting along with your visitor and want to progress the conversation beyond your personal responses to the art, price is the next topic to broach. I like to be fairly direct, and there are a few ways of doing this successfully.

Being Direct about a Sale

If after discussing a piece of art you can see that they are even mildly interested, you can say, "Would you like to own this piece?" That might catch them off guard and they will

> *Art is perhaps one of the more difficult things to sell, and to buy, and like any commodity, the consumer needs to be encouraged to buy your product.*

say, "Uh. I don't know, maybe." Most likely they will say yes, because they have been looking at the art with you and have already become personally invested with it. Now that you have gotten this far, it is your turn to say with affection, "I would really like you to have it if you really like it." Then you can discuss the price. You can suggest a down payment of $300, or whatever you think is a reasonable amount, and then wait for their next question which should be, "How much is it?" At that point you can tell them that while negotiable, the price is $3,000 (or whatever price you have in mind) and can be paid in monthly payments.

A Matter of Style

That is just one route to a sale. I gave that specific example so you could see how an actual studio sale might take place, but yours might be very different. However, if you remember the basic elements of the sale, you will be fine. Keep in mind what it takes to encourage someone to buy your work. They have to fall in love with it, and it's your job to see that that happens. The most subtle and crucial task is getting them engaged in your work. You can do this in many more ways than what I mentioned earlier, but that must not be forgotten. Help them talk about your artwork and treat their opinions as the special gifts that they are and use them to help make the sale. Art is perhaps one of the more difficult things to sell, and to buy, and like any commodity, the consumer needs to be encouraged to buy your product. Be mindful of

this, because you might feel comfortable talking about art, but most people do not.

Traditional Studio Visit Aided by Facebook

That was the classic structure of the studio visit and sale. Now that we are in the new millennium, there are a few more tools we can use in the sale. If there has ever been a video of you discussing your work, you should show the video. You can use social networking sites like Facebook and Twitter to help bring people to your studio. I am not talking about groups of people but individuals who might come and buy your work. They could be anyone. Facebook lets us easily search for collectors and make connections. We used to meet new people at museum and gallery openings (and we still do), but now we can make real meaningful connections through Facebook as well.

You Must Write, Even If You Are a Painter

Writing skills are important. What will you write to collectors on Facebook to get them to your studio? I will make suggestions, but ultimately you must decide what will work best for you. It is very much like dating, and you must think about what will sound attractive to collectors? Would you go to someone's house on the first date? Put yourself in the collector's shoes and think about what it would take for you to meet an artist you are unfamiliar with.

What to Write

Consider what would make you feel comfortable. There are several approaches to writing an effective invitation.

Facebook and email messages do not need to be formal, but it helps to be polite and not too casual. I always say Dear X, when addressing someone. I think beginning a letter with Hi is too informal and lacks style and courtesy. I am not Mr. Manners, but everyone likes to be treated respectfully. Here is one example of how extreme politeness can be helpful.

The Politeness Cure to Anger

I have a son in Taekwondo classes and the teachers (or masters, as they are called) are from Korea. Master Kim (Kim Sangpil), who owns the school, has an authentic Korean way of greeting parents. He always bows when I see him, and if he shakes my hand, he does so with both of his hands. He always addresses me as "Sir," and I do the same. The children in his class also call him sir when answering questions, "Yes Sir, no Sir." In return, when Master Kim addresses the students, it is always with the same level formality. This is a practiced tradition of creating mutual respect. Bowing still feels strange to me, but it is also comforting somehow. When I sit with other parents and watch our children, we act as we normally would—we do not bow or greet each other with formal titles— but we enjoy the formal atmosphere. This code of behavior does not mean that the master is not warm and friendly; in fact, he is very friendly. He always hugs the children, plays games with them and has a way of enthusiastically and sincerely complimenting them that makes the children very happy. I have watched this for over a year and never thought much about it until one day I had a verbal conflict.

Practicing What the Master Teaches

I was leaving on vacation to a small island off the coast of Rhode Island, and I had to park my car a certain way to get in line for loading it onto the island-bound ferry. As I was attempting to get in line, a man came over and asked me, "what the hell I was doing." He was in charge of getting the cars in order to board the ferry. His strong words and tone surprised me, and I told him I was trying to get on the boat. He starting yelling at me, saying it wasn't time yet, that I was doing it wrong, that I should "back the hell up and park over there" (pointing back in the direction I had come from). I felt humiliated, like a child being yelled at in public, and also angry that this guy was such a jerk. I started to park the car and had every intention of going over and telling him how angry I was, and how poorly he was doing his job, and then complaining to his boss.

Pausing a Moment

As I parked the car, a different thought came to me. I thought about Master Kim and how he talked about treating people with respect at all times. So I decided to experiment. I went over to the guy, who was now red in the face and yelling at someone else, and said, "I am sorry, Sir, if I parked my car wrong, but thank you for your help, Sir." I might have even bowed slightly. Then this agitated bull of a man suddenly calmed. He apologized and said I hadn't really done anything wrong, that the parking process was confusing, and that he was having a tough day. I was amazed that such a small gesture of respect could both disarm the person who had antagonized

> *Politeness is what you should aim for in your email messages to collectors. Addressing someone as "Dear" and signing off with "Best wishes" may seem insignificant and not reflect your normal voice, but to the recipient, these touches create an air of respect and professionalism.*

me, and calm myself as well. This experience taught me a valuable lesson about diffusing tension in potentially hostile situations.

Formal Manners Can Pay Off

This kind of politeness is what you should aim for in your email messages to collectors. Addressing someone as "Dear" and signing off with "Best wishes" may seem insignificant and not reflect your normal voice, but to the recipient, these touches create an air of respect and professionalism. The agitated man I spoke about didn't miss the fact that I addressed him as "Sir," and that helped calmed him down. I am sure he wouldn't address people that way, but it doesn't mean he doesn't appreciate receiving that courtesy himself. The same principle applies to the people you write to, no matter who they are. You can still joke around or be vulgar, but if you do so in a respectful way, your message will be better received.

Short Notes and Meeting Places

When writing short notes to people on Facebook, be clear about wanting to meet them and apply some of my suggestions. When I do it, I always ask if I can meet them at a cafe near their work. If you are trying to meet someone for the first time, it is safe to ask for a meeting in a restaurant or somewhere they are used to going. In the first letter, I always ask if they are interested in meeting. Once I get a response, I ask where would be a convenient place for us to meet. One way

to increase the likelihood of getting a response is to mention that you have a mutual friend. I am not talking about the Facebook friends (whom you may or may not actu-

> *Most people are just like you: They are cautious, and would like to know a bit about someone before they meet for the first time.*

ally be close with), but the people that you actually know and communicate with on a fairly regular basis.

A Designer's Technique for Landing Clients

I have a friend who does very high-end construction jobs in New York City, and when he is trying to get a job he knows other people are bidding on, he employs a few tactics to set himself apart from his competition. One is to handwrite a letter on nice stationary with a fountain pen, and the other is to use his network to gain the inside track with the employer. Sometimes, if his network (group of real friends) is not connected in any way to the client, he will try to meet the client's friends so that he can learn more about the client and claim to know some of the same! This process works for him, and he is extrememly successful in New York. It is all personal in many ways, so the more time you take with your letters and connections, the better.

Common Courtesy

Most people are just like you: They are cautious, and would like to know a bit about someone before they meet for the first time. Even if you do not have a mutual friend with the person you will be meeting you might have other points of similarity (the same college alma mater, experience living

in the same town, or perhaps you both visited a recent art exhibit). These are all things that can also make someone feel more comfortable about meeting you. Take your time and do your research before writing so that you can better tailor your letter to each person. Internet profiles, press releases, and media clippings can give you clues about how to make your approach based on the current interests of the person.

Following Up

Writing this short, polite letter requesting a meeting should be the easy part. The hard part for most people is following up when you do not get a response. This is usually the part where people give up because they take a lack of response personally and assume the person doesn't like them when they don't write back. I will tell you a few stories about my own follow up, and also one of my friend's stories. She was working at a major publisher in an upper-level executive position, making a six-figure salary, and was happy with her job. But she felt her boss was sexually harassing her. She filed a complaint with human resources and they told her that her situation was unfortunate and she had two choices: either stay on after giving a formal complaint and see how it worked out, or quit and they would give her six months pay and a coaching system and mentor that she could use until she got her next job. She thought that having a coaching program for as long as needed to secure the perfect job was an attractive offer. That alone was worth thousands, so she took it. As she told me this story, she also showed me all the printed material she had received on getting the perfect job from her coach. While reading it,

I came across a passage on how to get someone to respond to a letter.

You always deserve an answer to your letter, even if they do not have the time or inclination to meet, so I would pursue them until you get one.

How to Land an Interview or a Meeting

The section began by saying that most people who send their resumes and cover letters complain that no one ever calls them back for an interview, and further stated that this is the reason that most people don't get the job they are after, and why they become resentful. Artists can relate to this as well. Writing to collectors, museums, and galleries and not getting responses can be frustrating.

The Way to Handle No Responses

My friend's coaching material details the proper way to handle not getting a response. When writing a letter, it says, always end by saying that you will follow up with a call in two days. Be precise and never forget to say it. That way, the reasoning goes, you will remain in power and never have to wait for a call that isn't coming. If you call in two days and get voicemail or a secretary, simply say that you are following up per your email and will send another email in two days. Every correspondence should end with you saying that you will follow up with the alternative method to what you have just done—a phone call or email. In this way you can pursue people for weeks or months—however long it takes to reach them.

Get an Answer

You always deserve an answer to your letter, even if they do not have the time or inclination to meet, so I would pursue

them until you get one. Sometimes artists tell me that they don't want to offend people by calling so much, and that they are afraid of burning a bridge. That should not be a concern. Even if you did lose a new contact, one person who doesn't want to speak to you will not ruin your career. It is unnecessary to fear angering someone by pursuing them politely. If your intentions are honest and good-willed, and you are being professional and sincere about wanting to work with them, why would they be offended? Your tenacity should encourage them. When you keep writing to people, you are showing passion and drive, and people admire those qualities and respect the people who possess them, so please, do not worry about bothering people. As long as you follow what I have said here, you will succeed in most cases and save yourself the heartache of feeling ignored and rejected.

Talking to a Major Curator

Here is a story of how I got into a major New York museum that also has a museum in Europe. I had met the curator once, and I had a meeting with her at her office by contacting her as I have outlined in the previous pages. She told me she didn't work with contemporary art like mine, but she enjoyed looking at it, and she visited my studio shortly afterwards. I didn't ask her for anything at the time, but two years ago, I decided to call her because my wife and I had an idea for a show in their Europe museum.

The Phone Call

I called her cell phone and she picked up right away. I told her who I was and she remembered me. I explained our idea for

their Europe museum, and I
wanted to know who I could
contact about it and how I
could reach them. She told

> *When following up with a curator, be persistent, and do not interpret silence as a negative answer.*

me that our proposal sounded interesting gave me the contact
information I would need. But she also told me to hold off on
contacting them because she would call them first to explain
who I was. Four days later I still hadn't heard back from her,
so I wrote to remind her that I wanted to contact the other
museum, but was waiting for her to send confirmation that
she had spoken to them. Then, I proceeded to follow up with
the process I outlined earlier.

Over Two Months of Follow Up

Starting in May, I began to email and call her at least twice
a week, sometimes more. After a month I was amazed that I
had not heard back from her. What I found even more trou-
bling was that I was calling her cell phone and I could tell by
how quickly my calls went to voicemail that they were not
being accepted manually, most likely. After almost another
month of this I was starting to get worried. Did I say some-
thing wrong? Like everyone else, I began to think I had some-
how messed up my chance, but I couldn't understand how. I
knew that even if I had messed something up, I still wanted
a response. I felt I deserved an answer, and even if she had
changed her mind for some reason, I wanted to know. So
after about two months and at least fifty emails and calls I
changed my pattern—change is sometimes necessary in cas-
es like this. After starting the email in the usual polite man-
ner, "Dear X," I said that I was concerned that I hadn't heard

from her and that I hoped she was all right. Then I continued the letter as usual.

A Response

She wrote back the next day saying she was sorry, that she was writing a book and had been out of the office more than in, and finally that she had called the people at the other museum and they were waiting to hear from me. Isn't that remarkable? I was beginning to doubt her interest in the project, but she was just very busy, and I was not a high priority. So that was a story involving a high-level curator. But of course, I could have stopped writing to her much sooner, and clearly that would have been a mistake.

This next story is quite different.

Local Library Follow Up

I wanted to give a free lecture at my local library on income strategies for artists. A friend told me to go to the library and speak about it with the head librarian. So I went to the library and asked to speak to her, but they told me she was busy and to send an email. I explained that a friend had referred me and that since I was there, it would be just as easy to talk to her for a minute. They gave me the internal office phone and when she answered I explained that I wanted to give a free lecture at the library. She told me to send an email, so I went home and emailed an outline of my lecture. I didn't hear back from her, so I called, got an answering machine, and then sent another email. I still did not get a response. After two weeks I couldn't believe I was

having this much difficulty at a local library. I tried calling at different times of the day and sent more letters, still with no answer. Again, like any human being I was getting worried and agonizing over what I might have done wrong. But as in the past, I was determined to get an answer one way or the other, and when I finally got her on the phone I asked if she had received the emails? She said with a laugh, that she had, but asked me to send it again so that it would be on the top of the mountain of emails she already had. So right after I got off the phone, I sent her the email again and then called her right away. She said she had received it, and yes, of course she would like the lecture at the library. Right there on the phone she booked it in her calendar and it was finalized.

Don't Take It Personally

Even though the librarian was not as highly sought after as the curator, the same rules applied when corresponding with her. She was very busy, perhaps overwhelmed with budget cuts and mounting work, and her lack of response was nothing personal, she just had higher priorities. Keep these stories in mind as you pursue people, because in this growing, competitive world, one must often be persistent. Take heart though, and remember that we are all struggling in our own ways, and it is usually not personal. We are all just overwhelmed with our own responsibilities.

Museums, Galleries, and Purity

M̲useums function very dif-
ferently than galleries, and they have different goals and
approaches to art. Museums look for projects that expand
the definitions of art and they are looking everywhere for it
from the Middle East to Brooklyn. A museum wants to bring
in something that educates, and since almost all curators and
museum directors are academics, they are looking for some-
thing they understand and that they feel is important.

Museum versus Gallery

It is important to understand the differences between muse-
ums and galleries so you know that preparing to approach one
is very different from preparing for the other. Unless a gallery
is a co-op run by artists or a nonprofit space (both of which
make little or no sales), it has really only one goal—to make

> *Even if your art is stunning, the gallerist isn't interested in liking you or your work as the priority. She has a very serious financial decision to make about whether your work will likely bring them a good financial return on their investment, which is giving you a show.*

a good profit. This is because galleries cost money to run, and their shows usually sell very little, so the sales they do make need to be as high end or commercial as possible so they can pay for all their business expenses. By necessity, galleries are less interested in the art than its ability to sell. The upside is that you can make a gallery an offer they can't refuse, and that is generally a no-no for museums.

Making a Deal the Gallerist Cannot Refuse

A deal you cannot refuse is a staple in any businessperson's repertoire. It means that you present yourself and your proposal in such a way that is impossible or nearly impossible to refuse because it's clear that everyone wins. If I ask you for $100 and guarantee that I will give you $200 in a week, would you refuse? That's an example of a deal you cannot refuse. If you trusted me, you would pay me $100 because the deal clearly works in your favor. This, in essence, is the basis of any proposal that is difficult to refuse. It doesn't matter if you are talking to a gallery, an investor, or a business partner; the other side wants to know what is in it for them, and they want to take as little risk as possible.

It Isn't about Your Art Alone

That is why just showing your work to a gallery is not nearly enough. Even if your art is stunning, the gallerist isn't interested in liking you or your work as the priority. She has a

very serious financial decision to make about whether your work will likely bring them a good financial return on their investment, which is giving you a show. Museums are different, and we will discuss them soon, but galleries must think about profits. If they didn't, you would not want to be with them. The reason you seek galleries is to sell your work, so why would you sell to a place where selling your work wasn't their main objective? Sometimes you may find very small, poorly run galleries similar to small, unambitious businesses, and they may not be motivated to sell your work and having good shows. Do you really want to be there?

The Bigger Galleries

The best galleries in the world are able to combine a lack of financial risk with a sense for what is some of the best art in the world at the highest prices possible. If you want to exhibit in a gallery, you must think about what they are looking for. An artist is also a businessperson who wants to partner with a gallery so they will sell their artwork. If you want to have success with galleries, think about what you can offer them.

Making an Offer and an Event

You might present something to a gallery that includes an event like a band on opening night, a fundraiser, or anything else that would help bring in a crowd. Be sure to share any marketing ideas you have and invite your collector friends as well. Here, you can be as creative as you like, but to begin with, just think about ways to bring in a crowd so that you have a greater chance of making sales. If you have an organization you would like to give money to like the Red Cross, you can

Outrageous things also get the media's attention, but commonplace things like jugglers and ice cream giveaways can also work.

advertise at your event that a certain percentage of the proceeds will go to that organization, and this may also encourage people to buy your work.

Use Social Media and Stunts to Promote Your Show

Other ideas for marketing your show could be creating events on Facebook and promoting them with Twitter, Instagram and other online social platforms. It's important to do whatever you can to draw media attention attention because galleries want more public exposure. Think about a way to make the news. One way could be breaking some kind of record. Richard Serra makes some of the biggest and heaviest sculptures in the world; Marina Abramovic, a performance artist, had a show recently she claimed to be the longest performance in the world. Whenever someone attempts to break a record, it becomes news. Outrageous things also get the media's attention, but commonplace things like jugglers and ice cream giveaways can also work.

Gallery Invitations That Work

I get invitations to shows all the time, and I can't go to many of them because I am either writing, making art, or spending time with my wife and son, but when I got an invitation to a gallery and read there was going to be juggling, free ice cream, original poetry readings, and a band, I decided take my son and check it out. Can you see the fun-for-the-whole-art-family attraction in an event like that? Many journalists have social and family lives they are managing with their

professional lives, and they are looking for ways to combine them. In this instance, I didn't go to the gallery for the art, but for all the activities happening around it. My son liked the ice cream, my wife and I enjoyed the poetry reading, and the art was nice as well, and I met some new people. The event was held at a co-op gallery, which I usually avoid, but I was actually quite impressed with the art I saw so I might go again sometime.

Effective Openings

The reason this event was so successful was because it had something for everyone, from kids to adults, and the show was fairly easy to understand. Plus there was free food and music. Another reason this show was packed was because so many people were involved. In addition to the event organizers, there were poets, writers and musicians, and they all invited their friends to the show as well. That is why group shows usually draw large crowds. When you propose your work to a gallery, you might also think about including other artists as well.

Collaborative Exhibits and Proposals

Artist-curated shows are more popular now, and it is OK to include your own work if you are up front about the show being curated by an artist. Also, the show could have a theme that supports your work. For example, let's say you paint flowers. It would be helpful to recruit other artists who paint flowers. You could also ask a local florist to donate flower arrangements and demonstrate for your guests how to arrange them. Try to be creative and come up with other flower-related events. If your paintings are abstract, bring in other abstract painters

and sculptors and stay away from anything figurative. Again, you could also have activities like readings and music, but what about staging a reenactment of a Jackson Pollock painting? It is important to have fun with these things. Galleries will then find your ideas interesting. You are not saying, "Do you like my work?" You are creating a rich experience that will help draw crowds, press, and most importantly, sales.

Museums

Museums are a different ball of wax altogether. They are not in the business of making sales and are not concerned with selling their collections in most cases. In fact, talking about sales with a museum would generally be a mistake for several reasons, unless you're talking about their gift shop. Museums know that exhibits increase the value of living artists, and they are careful to avoid involvement in commercial deals for ethical reasons.

Galleries Want Museums

You see, many galleries don't understand how museums work, and for this reason have difficulty getting museums to take their artists' work. It is a mistake to approach museums like you would other for-profit businesses because museums do not run on art sales and are unlikely to be interested in the gallery's proposals.

Museums Do Not Want Galleries, They Want Art

Museums are not easily seduced, and indeed, tend to be put off by dealers who try to woo them into looking at an artist's work. All the museum wants to know from the dealer is

why the artist is interesting, and what, if anything, can the artist's work teach the public. Museums, not unlike universities, are essentially educational institutions, and they make money by charging admission and having fund raisers. The staff of a museum is largely made up of academics who have at least a graduate degree.

> *Artists must understand the importance of their work's educational value, because if they approach a museum with a proposal of some kind, they must be able to convince the museum that their work is of value extrinsically, in the form of workshops, lectures, and other possible forms that would benefit the public.*

Approaching Museums

When I advise galleries on how to approach museums, I tell them to focus on an artist's educational value. The gallery must consider how their artists teach or help their viewers understand something in a new and different way. How is the artist building on the history of previous artists? Artists, too, must understand the importance of their work's educational value, because if they approach a museum with a proposal of some kind, they must be able to convince the museum that their work is of value extrinsically, in the form of workshops, lectures, and other possible forms that would benefit the public.

Education versus Curatorial at Museums

Curatorial and education are the two main departments in museums. The curatorial department is in charge of what exhibits are produced and what catalogs are published about those exhibits. Even in the most contemporary museums like the Museum of Modern Art in New York, most of the curatorial staff is involved with research.

Curatorial Department

Museums mainly seek famous and deceased artists whose work fits into the museum's particular educational category. For example, if you are a curator in a modern museum of contemporary art, one of your projects might be to look at drawings from the past fifty years and compare them to show how style and technique has changed over time in a particular field. Looking at drawings from the past that were used as journalistic tools, would be an example that could be compared to the present.

Research Is Mostly What a Curator Does

A curator may look at paintings from a particular decade and compare them with political events at the time to find relationships between art and politics. I'm explaining what curators do, very briefly, so that you understand that these are not people who can easily help you exhibit your art—their work is entirely separate and may have little to no influence in those matters.

Any Museum Relationship Can Get You Far

However, any connection at a museum can be helpful. I will explain how in just a moment. The other department at museums is the educational department, whose sole purpose is educating the public through programs rather than exhibits.

Educational Department

The easiest way to understand about educational programs is to go to a museum website, preferably for a museum near you, and look at what they have to offer. There will be

upcoming exhibits, of course, but there will also be educational programs for the public. Many of these programs are designed to appeal to specific age groups. They might also have tours for adults at different times that are focused on the current exhibits.

Workshops

They will also have workshops for young children, teenagers, college students, and adults. There are several different kinds of workshops. Some of them involve participants making something with their own hands, some are lectures, and still others involve playing games that help demonstrate how particular exhibits work. It is also popular now to have drawing packets that teach children to use their imaginations in new ways.

Adult Education

Entertainment is also a goal for adult education. Education-al departments try to offer programs and create learning-friendly atmospheres where adults and kids alike can come to understand and explore artwork. I was recently reading about a museum that created a lecture series based on things that didn't go together. An example would be a lecture on the philosopher Nietzsche and pictures of Puppies which the museum had and was very popular! Both entertaining and educational.

Your Career in Education and Also Curatorial Departments

The educational department is very important to your career, because it is the easiest way into a museum. Besides getting paid, you can meet the right people in the curatorial depart-ment for a possible show. To begin, what you'll want to do is to propose a workshop or tour of the museum (if you look at the museum's website you will see what kinds of things they are doing already).

Propose an Educational Workshop

Generally, I have found that museums have boring educa-tional programs, and that is because not enough artists submit proposals. The people submitting proposals are often educa-tors who have very traditional experience with audiences. As an artist, you can probably do better. The Metropolitan Mu-seum of Art in New York had a popular program where art-ists gave tours of the museum, pointing out and talking about their favorite pieces. This got a lot of press and became a big

success because artists talk about art in a very different way than educators with no special art knowledge. Artists have informed opinions, strong likes and dislikes, and

> *The reason you are proposing workshops is to get into the museum, get paid, and have an inside connection to the curatorial department.*

can be quirky and engaging in their presentation. The public enjoys this much more than most docents, who drone on monotonously during their tours.

Submitting a Proposal to a Museum

Let's move on to how you will submit your idea to the educational department. Keep in mind that you are doing this to get into the museum, get paid, and have an inside connection to the curatorial department. The best place to start is the museum website, where you will find a listing of their current educational programs. Look them over, notice how they are written, and decide which ones appeal to you and which ones do not.

Research, Then Write

When you are going to write a proposal for an educational program, the museum's website is the best way to research what the museum might be looking for. Let's say there's a local museum that you want to approach. After looking over their currently offered educational programs, think of one you could do. To jumpstart your process, also look at the museum's upcoming exhibitions. Most educational programs are related to the current exhibits, but you need to know what the museum is planning in a year or six months so you can see if you can do something appropriate then.

The Current Exhibit

If the museum you are looking at has a Picasso exhibit coming up in four months, you might want to think of a program that will help people to understand Picasso. An example could be an adult workshop taking digital self-portrait photographs, ripping them up, and then gluing them together, similar to Picasso's paintings. The goal would be to teach how Picasso worked with angles and different perspectives to add complexity to his work. With a hands-on workshop like this, all ages can learn something about an artists' process.

A Related Workshop

An idea like that would certainly be considered, but there are tons of other ideas you could come up with. Think about age groups, and remember to make your idea fun. Could you adapt the workshop I just mentioned for small children and senior citizens who may not be able to use a computer? Perhaps Polaroid's could be taken, or digital self portraits could be printed out, ripped up by hand and glued back together.

Tours

If you are interested in giving tours, you could propose doing one, or a series of tours with a new twist to make it fresh and interesting. You could talk as an artist, or perhaps impersonate Picasso or an important person from his life, and give the tour in character. Once you have an idea, write it out in a short, clear draft. The best way to learn the proper form and length is to go to the museum website again and read over the pro-

gram descriptions. Copy this form exactly. Make it sound like your program is already done and ready to put into operation by including the program's age range and sign-up information. That makes it much easier for the museum to imagine your program in their facility.

Contacting the Museum

Who do you send your proposal to? Normally, you would send it to the Program Director, who should be listed on the museum's website. When I am having trouble finding the right person, I call the museum and ask the general information desk who is in charge of educational programs. They can give you the number you need and sometimes transfer you directly, so be prepared to talk about your idea when you make the call. All you have to say is that you want to submit a proposal for an educational workshop, and who should you send it to. Once you get the right contact information send your proposal as an email, and follow up every few days with calls and emails until you get a response.

Why This Works

You might still think this strategy is hard or competitive, but it is not. Also, once you are running workshops and getting paid—yes, the museum will pay you—then you can ask to meet the museum's curators who work with living artists.

The Guggenheim Museum in New York

To close this chapter, I will tell you about a time when I was invited to the Guggenheim Museum in New York and the

director of educational programming gave me a tour of their facilities. I had called and asked to see the spaces they had available for workshops and educational programs and the director took me around to the beautiful spaces inside the museum, and explained what each room was used for. One room, which looked like a large conference room, had about thirty equipped computer stations.

Unused Resources

The director told me that IBM gave the museum these computers and funded the room, but that no one ever used it. I couldn't believe what I was hearing. The Guggenheim Museum had a whole room of computers that could be used for educational purposes, and they just sat there collecting dust! The director explained that no one had any idea how to incorporate the computers in helping people understand their exhibits. He laughed and said, "That's how things are!"

Opportunities Abound

If that can happen in New York City, there must be numerous openings for educators across the nation. You are an artist, a visionary, and an educator. You don't need a degree or past experience to do this; you just need an idea and the will to see it through to fruition.

Chapter 13

The Artist Statement

It is necessary for you to have a biography and personal statement for your applications, but there are ways around the form's rigid structures so you can write something truer to your own voice that is easier to understand.

Artist Statements

Artist statements are perhaps the biggest stumbling block, and one of the most misunderstood pieces of writing. I owned a gallery for several years and received a lot of letters from artists with images and artist statements. I am, and presumably, so are most people in this business, a visual person, and when I got materials that looked good to me—in other words, that the images were compelling somehow—I was excited. However, many artists lost my interest with poorly written artist statements. When I see art, I know if I am attracted to it or not. I may not know why, but like anyone, I can point and

> When I was a gallery director, I noticed that many times after reading an artist's statement, the work that I was initially attracted to was no longer appealing!

say, "I like that one the best." It is hard for people to put into words. The cliché is that a picture is worth a thousand words, and I think it is probably more than that. There are so many responses we have to an image on a conscious and unconscious level that it can be almost impossible to understand all the reasons we are attracted to it. So when an artist's statement tries to explain an image, it can be like artlessly explaining a poem, which removes all its beauty.

Bad Statements Can Be an Artist's Undoing

When I was a gallery director, I noticed that many times after reading an artist's statement, the work that I was initially attracted to was no longer appealing. I remember one statement from an abstract painter who described his work as "lyrical abstract surrealism." It was an awkward phrase, and the statement about how he was creating a new genre was even worse. He would have been better off saying nothing. Although I liked the work, I decided not to show it or continue the correspondence because I didn't think I would enjoy talking to this artist whose statement was pretentious and unnecessary.

Write Less, Write Sincerely

Many artists think their statement has to be a manifesto of some kind, or a grand declaration about their work, but that is not the case. One of the best-selling artists in the world is Marlene Dumas, a contemporary painter whose work is mostly figurative. Much has been written about her work and

what it means. Her well-known artist's statement is very simple: "I paint because I am a dirty woman." It is a wonderful statement because she is showing a sense of humor and also being slightly erotic. If you saw her images and liked them, you might read her statement and smile a bit, but it would probably not turn you off. If I were evaluating her work and read that statement, I would think she has a sense of humor and might be fun to talk with. The work itself shows how serious she is, and the statement shows her wit and hints at her personality without feeling arrogant or pretentious. However, her statement is actually much longer, closer to a poem and that was just one line in one of the most powerful statements I have ever read. The statement in its entirety is below.

Woman and painting

By Marlene Dumas, painter

I paint because I am a woman. (It's a logical necessity.)

If painting is female and insanity is a female malady, then all women painters are mad and all male painters are women.

I paint because I am an artificial blonde woman. (Brunettes have no excuse.)

If all good painting is about color then bad painting is about having the wrong color. But bad things can be good excuses. As Sharon Stone said, "Being

blonde is a great excuse. When you're having a bad day you can say, I can't help it, I'm just feeling very blonde today."

I paint because I am a country girl. (Clever, talented big-city girls don't paint.)

I grew up on a wine farm in Southern Africa. When I was a child I drew bikini girls for male guests on the back of their cigarette packs. Now I am a mother and I live in another place that reminds me a lot of a farm – Amsterdam. (It's a good place for painters.) Come to think about it, I'm still busy with those types of images and imagination.

I paint because I am a religious woman. (I believe in eternity.)

Painting doesn't freeze time. It circulates and recycles time like a wheel that turns. Those who were first might well be last. Painting is a very slow art. It doesn't travel with the speed of light. That's why dead painters shine so bright. It's okay to be the second sex. It's okay to be second best. Painting is not a progressive activity.

I paint because I am an old-fashioned woman. (I believe in witchcraft.)

I don't have Freudian hang-ups. A brush does not remind me of a phallic symbol. If anything, the

domestic aspect of a painter's studio (being "locked up" in a room) reminds me a bit of the housewife with her broom. If you're a witch you will still know how to use it. Otherwise it is obvious that you'll prefer the vacuum cleaner.

I paint because I am a dirty woman. (Painting is a messy business.)

It cannot ever be a pure conceptual medium. The more "conceptual" or cleaner the art, the more the head can be separated from the body, and the more the labor can be done by others. Painting is the only manual labor I do.

I paint because I like to be bought and sold. Painting is about the trace of the human touch. It is about the skin of a surface. A painting is not a postcard. The content of a painting cannot be separated from the feel of its surface. Therefore, in spite of everything, Cézanne is more than vegetation and Picasso is more than an anus and Matisse is not a pimp.

—**Marlene Dumas 1993**

Write with Humor

There is another artist whose statement I read recently, a Brooklynite named William Powhida. His work is often very political and narrative, and he pokes fun at the art world by pointing out hypocrisy and art scandals similar to insider trading. He is an artist and art critic at the same time. He recently had a print for sale on the website 20x200, a place

> *Your online artist statement has to be either very brief and memorable, or an extremely compelling story.*

where artists can sell prints. When artists submit their work, it must be accompanied by a short statement as well. The print he was selling had the word "fuck" written in different styles and colors all over it, maybe 200 times. His artist statement read: "It would make a good shower curtain too." His sense of humor, like Marlene Dumas', is refreshing.

Reading Is Different Now

We are living in an age where people scan the Internet. Unlike traditional reading, people tend to scan Internet pages quickly, looking for pertinent information and facts, and then move on. Your online artist statement has to be either very brief and memorable, or an extremely compelling story (whether it is fact or fiction does not matter). But like a good article or novel, the first sentence should pull the reader in.

Write with Intrigue and Mystery

Here is a statement by artist Joseph Beuys:

> Had it not been for the Tartars I would not be alive today. They were the nomads of the Crimea, in what was then no man's land between the Russian and German fronts, and favored neither side. I had already struck up a good relationship with them, and often wandered off to sit with them. 'Du nix njemcky' they would say, 'du Tartar,' and try to persuade me to join their clan. Their nomadic ways attracted me of course, although by that time their movements had been restricted. Yet it was they who discovered me in the

snow after the crash, when the German search parties had given up. I was still unconscious then and only came round completely after twelve days or so, and by then I was back in a German field hospital. So the memories I have of that time are images that penetrated my consciousness. The last thing I remember was that it was too late to jump, too late for the parachutes to open. That must have been a couple of seconds before hitting the ground. Luckily, I was not strapped in – I always preferred free movement to safety belts . . . My friend was strapped in and he was atomized on impact—there was almost nothing to be found of him afterwards. But I must have shot through the windscreen as it flew back at the same speed as the plane hit the ground, and that saved me, though I had bad skull and jaw injuries. Then the tail flipped over and I was completely buried in the snow. That's how the Tartars found me days later. I remember voices saying 'Voda' (Water), then the felt of their tents, and the dense pungent smell of cheese, fat and milk. They covered my body in fat to help it regenerate warmth, and wrapped it in felt as an insulator to keep warmth in.

—Joseph Beuys

Why Is That a Good Statement?

The first sentence is about life and death. When I read the statement aloud during lectures, there are usually audible gasps when I read the part about the copilot being atomized on impact. Current research says that the copilot actually

lived, and there were no Tartars in the region at that time, but in a dramatic piece of writing like this, no one is interested in the truth, they want to be entertained. Notice also, how the artist doesn't describe the art itself. The story stands on its own as a memorable narrative about a transformative experience.

Survival and Trauma

As an artist, Beuys often used materials like felt and animal fat. To interpret what he was trying to say with his work was not easy, but after reading this story, stacks of felt, a chair with animal fat, and a sled, suddenly have a very clear meaning about life, death, and the experience of being saved. Looking back at his career and life, we can see he was actually creating a sort of mythology around who he was. That would not be very interesting if he wasn't also doing work that challenged our sensibilities and made us think.

What Will You Write?

Your artist statement could be like either of the ones I just mentioned, or it could be something completely different. The main thing to keep in mind is that it must be easy to understand and exciting. If your writing skills aren't great, you would be wise to have a writer help you. Even writers need editors to help them present their ideas in the best way possible, so if you want a good statement and are struggling on your own, ask for help. Have a writer read this chapter and then discuss different possibilities with them. It is very important to have a great statement because, as a former gallery owner, I have seen how this first impression can make or break an artist's proposal.

My First Statement

When my wife and I first began working together, our idea was to give out hugs through our storefront in the East Village in New York City. When we applied to shows we also needed an artist statement, and since we had just fallen in love and were using art to share that love, we considered using love or spirituality in the statement. Ultimately though, we decided not to use "love" or "spirituality," not because they didn't apply, but because the words are overused, are too nonspecific, and would probably not help the viewer understand what we were doing. Instead, we made up an analogy, using the language of software developers, which served our purpose. Here is the statement my wife and I wrote about our art work which involved giving out hugs and washing feet, in the third person:

Manifesto/Statement of Praxis

Praxis Software Development Team

Similar to the synapses occurring throughout our brains, the spaces between the neurons where nerve impulses are transmitted, the software team creates the synthetic equivalent of the chemical substance serotonin, which bridges those gaps. It is the mechanism that creates the spark and connection that lets us log-on, so to speak, with our limbs and higher functions. It is not the acts or performances that are central, but the software that is created by the practice and ongoing quality of the documented exchanges. The software that they manufacture is designed to make new paths for our own hardwired hardware within our systems which seek additional programming for smoother, faster, and more elegant operation.

Software Development

Designing a new operating system; Praxis OS 33.1

Through weekly demonstrations at the Tenth Street studio, the software is revealed, so that others can download the shareware or integrate the program into their own operating systems, which is the well-known and popular central nervous system. Once it

has been installed successfully, it quickly becomes a beneficial virus that multiplies and begins an overhaul of current systems creating a new parallel operating system within the old one, which is more flexible and can share information with enhanced ability. As a software development team, they use their own systems as experimental guides when inventing or altering their new OS. Developers Bajo and Carey found, through connecting their systems, a new virus-like activity which was beneficial to both systems, and soon they began deleting all other programming that previously assisted them, such as dairy products, alcohol, tobacco, drugs and caffeine. Their goal is to create an OS that will rival Windows or Mac X. This new system is built on a more organic model that incorporates artificial intelligence into our systems which, combined with the original and genuine model, creates a performance that runs extremely smooth with little or no crashes, and only a few bugs. When fully engaged, this OS will act as a fast igniter and stimulator so the human CNS will have an easier time encountering other systems with various programs and viruses that sometimes makes exchanges of information awkward, violent, and prone to crashes and disappointment. With Praxis OS 33.1, crashes are welcome, and in most cases, automatically self-repairing. As this new OS replicates itself all over the world, centers will be set up where new and old users can update, download, and log on.

Why That Statement Works

You can probably see what is happening here. Instead of talking about love, we are talking about our systems or bodies, and using terms like shareware and viruses to talk about our art. We are also not saying exactly why we are giving hugs and foot-washings, other than to remove the viruses in other systems. This is, of course, all a way to say we are trying to make the world a happier place one person at a time through hugs and foot-washings.

Myth Making and Being Sincere

This type of statement is similar to Joseph Beuys's. It is an analogy for how we work. You could write a statement like this no matter what your technique or medium is. Try using other terminology, like gaming slang, or anything else with its own special vocabulary. What is also interesting is that when a curator reads the statement or prints it for an event, they have to put it in their own words. The next section demonstrates how a curator used our statement to explain our work during our show at the Whitney Museum Biennial.

How a Curator Uses the Statement

The curator Debra Singer wrote the following in the museum catalog:

> For the three years, Delia Bajo and Brainard Carey, who form the two-person art and performance collaborative, Praxis, have used their storefront East Village studio in New York City to stage weekly afternoon events. As part of their New Economy project, this

husband-and-wife team has offered every Saturday a menu of four free services from which visitors and passersby may choose: foot washes, hugs, Band-Aid applications to help heal visible or non-visible wounds, and gifts of one-dollar bills. Using the rhetoric of systems management, Praxis describes itself as a "software development team" that uses the bodies of Bajo and Carey as hosts to test their operating systems. By receiving the benefits of The New Economy Project, participants become a part of Praxis's performance, and so choose to "download" the "shareware" created by Bajo and Carey, thereby integrating the altruistic spirit of Praxis into their own "systems." Though Praxis's language is contemporary, the character of its project draws on strategies from experimental performance art of the 1960s and '70s. Through direct, yet intimate interactions with the public, for example, the New Economy project recalls the activities of Fluxus, the radical network of visionary artists who sought to change political, social, as well as aesthetic perception through performances that were often absurd and shocking in appearance, yet historically pivotal at the same time. It also recalls the ideas of the artist and influential teacher Joseph Beuys, whose notion of "social sculpture" substituted the traditional understanding of sculpture, and art more generally, as fixed material objects for the definition of ephemeral actions and processes that could transform everyday lives. In analogous ways, Praxis, through their interactive, nurturing performances, offers alternative modes

of economic and social exchange that serve as a comforting antidote to the potentially alienating effects of today's world that is often dominated by technology and consumerism.

How the Museum Used the Statement

How the museum uses the statement is also important. In my case, they presented it in catalog text, which provided a way to talk about the work that had some humor, and also explained that the work is about changing the way we feel and how we function. You can see from this example how a curator uses and interprets a statement for their own reasons. This is why it is important to have a piece of writing they can draw from.

The Application Process

Statements also help with your applications. They are often necessary when submitting images to a juried show or for a prize, though in this case, their function is slightly different. Here's how a jury works, in case you've ever wondered. First, all the artist's work is organized in a projected display that the jury views in a dark room. Generally, there is a moderator in charge of organizing the images and identifying the artist to the jury.

The Jury Waits for You

Before the next artist's images are projected, the moderator hands out copies of the artist's application to the jury and verbally introduces the artist, saying something like, "The next artist is X, and I will read his/her statement." Then the moderator reads the artist's statement. This is an important scene

to visualize and understand because at this moment the jury isn't looking at the images yet and will be solely focused on the statement. After hearing the statement,

> *Your statement should be very clear and enticing, the same way the beginning of a good article or book will draw in the reader.*

the jury will already have a preconceived notion about what they are going to see, and a bias for or against that artist. That is how powerful the statement is in juries.

Your Statement is 90 Percent of the Excitement

Where juries are concerned, it may be better to have no statement at all instead of a mediocre one that risks making a bad first impression. After your statement is read, you want them to feel excited to see your work, not confused about what your art is. Therefore, your statement should be very clear and enticing, the same way the beginning of a good article or book will draw in the reader. If you can elicit a feeling of, "Wow, that sounds beautiful," or, "That sounds scary and intense, I hope I can handle it!," you've done a good job. You are simply trying to get them to look forward to your images.

New Frontiers:
The Non-Visible Museum

New methods of online communication keep emerging, and you can also invent one yourself. The current forms of communication continue to undergo revisions that are often necessary, and we are all challenged to use these updated versions.

Learn the Code

This is a last word on social networks in the Art World's final frontier; a hyper-complex world of algorithms that determine how we communicate online, changing based on which services we use, or news sources we read. Understanding how new systems are written is the code, like in *The Matrix*. We must all learn how to speak this new language and adapt along with it if we do not want the systems to rule us.

> *You can develop a stance on many of these new ideas, such as being a student forever, or being opposed to new forms, or limiting your time on new formats or even being an entrepreneur or pioneer in the field.*

Future Networks

If you are reading this book, you are aware of online social networks and may be using them. They are part of your language now, and that language will be used more and more. I am sure that parts of what I've said in this book are dated already because things on the Internet change so fast. There will be new online games, new ways of sharing information, new apps for your smart phone, and much more that will effect how your work is communicated to the public. You can develop a stance on many of these new ideas, such as being a student forever, or being opposed to new forms, or limiting your time on new formats or even being an entrepreneur or pioneer in the field.

Micro-Entrepreneurs

Of course I fall on the side of being a type of entrepreneur, or the path of the *Do-It-Yourself* artists, but this is wide open territory. A project I did with my wife that describes one new frontier, is coming up. Online business practices are constantly being revised and will most likely continue to do so. That means you are on the frontline as a creative person and an artist with the chance to do something potentially amazing and historic. From creating new applications that can work on smart phones and tablets, to new ways for the millions of online consumers to see and buy your artwork, the way the world connects through the Internet continues to

evolve. The people who create these new systems are pioneers because we all want better ways to share and communicate. Ironically, it seems an interactive touch-screen is one of the best ways to accomplish that.

Ideas Are Needed

I am not saying you need to be a software developer, but any idea you may have that could change the way we communicate through art can be game changing if you take it seriously. The art world is small compared to something like the world of health care or academia. There is usually very little funding for the arts. Look at a visionary project like Kickstarter.com. That was a game-changing idea. It was simple: make a pitch, give different "rewards" like artwork to investors, and hope you get enough interest to fund your dream.

The New Funding Paradigm

Incredibly, they started in 2009, and as of 2010, they were already the largest funding platform for artists in the world. Kickstarter.com is a wonderful place to go to look for more visionary ideas, and is also a wonderful example of how to creatively build a business that helps artists share their work and raises money for them. Even if you do not consider yourself an entrepreneur, you've probably had ideas before that you thought could be profitable. Your ideas are not selfish or crass or not possible or long-shots, just look at Kickstarter.com and you'll see that a good business idea can help everyone.

The Non-Visible Museum / the Kickstarter Project I Did with My Wife

In 2011, my wife and I started an art project called MONA, the Non-Visible Museum of Art. My wife and I do all our work together and the projects are usually high-concept art. For the purposes of this book, the story of how I raised over $10,000 in a week with an online art presentation will be both a course in how social media is used, and a course in the DIY (Do-It-Yourself) movement in art. What I describe may sound unusual or impractical to some, and you might have a hard time imagining how your artwork fits into this model, but you can use it to share your art with the world. Social networking, for all its pros and cons, is at the very least a giant game of show and tell, and as an artist, showing your work and telling a bit about it is what this book is a guide for.

How We Did It

The story I am going to tell is about an idea my wife and I had for a non-visible museum. We not only sold a lot of art, but we improved our

Clearly, my wife and I were taking artistic license by offering hugs to people. Of course the hugs were not the only art we were creating; we also made paintings, drawings, and whatever else we wanted to experiment with.

art careers dramatically and got international and national media coverage. You, too, can try many of the things we did to promote this project. This chapter assumes that you understand the basics of social networks, and if you do not know how to build web pages and manipulate HTML code a bit, you will have to talk to your web designer to understand some of what I'll be describing.

The Beginning

The idea of a non-visible museum was conceived in 1999 and 2000 when my wife and I met. We were artists living illegally in a storefront in the East. We had begun a project where we gave out free hugs, foot washings, and bandages for non-visible wounds to the public. We opened the storefront every Saturday and offered those services. People liked our services and asked why we were providing them, and we always replied that it was because we were artists who wanted to do this. That was the truth. As an artist, you can really do whatever you want. When we told people who we were they seemed to understand. People assume that artists have ideas and motives that they may not understand and give you what has become known as an "artistic license."

Artistic License

Clearly, my wife and I were taking artistic license by offering hugs to people. Of course the hugs were not the only art

we were creating; we also made paintings, drawings, and whatever else we wanted to experiment with. For starters, knowing you have artistic license to do anything you want will help you succeed. It's incredible how much latitude you have as an artist. My wife and I once interviewed Vito Acconci, a great artist and very interesting thinker, who told us that art, unlike science or math, is the only field of interest that is non-field, meaning that it can incorporate anything. In other fields, there are limits to what can be brought in to study and influence things within the field, but art is limitless.

Art Has No Limits

Artists can do all the traditional things like dance, sing, and paint, but they can also work, for example, with biologists or architects to enhance their work with new views and sensibilities. Everything influences an artist's work, and that includes modes of exchange and commerce. Artists can have a personal impact on this as well. Especially now, with the web at their disposal, artists can use social networking media for their own agendas. The MONA story illustrates how many of these tools can be used for our artistic purposes, and how you can use them, too.

Non-Visible Wounds

When we were giving out free hugs, we also gave out bandages for what we called non-visible wounds. We would ask people if they had any non-visible wounds of any kind and they would typically say no, or that they had headaches, stomachaches, heartaches, or other internal wounds of

some kind. For those with heartache we put Band-Aids on or near their hearts and give them motherly kisses on the bandage itself.

Thanks to having good visibility in our storefront, we made many new friends.

Community

Looking back on it now, those Saturday offerings were a great way of meeting people and sharing art. Everyone who came into our small 200-square-foot storefront for a hug or bandage was also exposed to the art decorating our walls. Artists do all kinds of things to get people into their studios (like having a party and giving away food and drink), but whatever you do, getting new visitors helps you grow. If you are not meeting new people whenever possible, there will be fewer new opportunities presenting themselves. The beginning of the Museum of Non-Visible Art story has its seeds in our first event that brought people into our studio for the non-visible bandage.

Thanks to having good visibility in our storefront, we made many friends new friends this way.

Having a Child

We developed different shows and exhibits over the next few years, but we also had a child and caring for him took a great deal of our time, because we also decided to homeschool him ourselves. Being able to spend so much time with our child was magical, and it influenced our work, adding a new sense of humor and playfulness. In 2010, our child was almost ten years old and could

handle more things on his own. That gave my wife and I time to launch a major new project.

A New Museum

The project was almost like the non-visible wounds we were kissing before, but this time we decided to make a museum that was not visible by describing how it would look. In other words, imagine someone is giving you a tour of a museum, only you are standing outside and there are no displays or walls with art on them. The tour guide gestures to the open air, or a blank wall, and talks about art that isn't there, and you have to picture what the tour guide is describing in your mind. But instead of doing a performance, we wanted to talk about visual art, like paintings, sculptures or installations, so this idea grew into a tour of a non-visible art museum. The more we thought about it, the more we liked it, because we realized the art that we described would not be limited by space or material concerns of any kind. We could describe giant sculptures that were astronomically expensive or physically impossible to build. There were no limits.

Sales Strategy

We liked the idea but there was the issue of sales—how could we sell art that didn't physically exist? We wanted to sell our ideas about the visual art in such a way that people focused on the art, rather than the tour of the museum. The next step in our thinking process was to develop a way to sell the art without the actual physical product. The solution we arrived at was to use the previously mentioned kickstarter.com because it is the

largest funding platform for the arts in the world. Similar to YouTube in its layout, Kickstarter allows you to upload videos describing the projects you want funding for, and

> The key to any project on Kickstarter is to create interesting rewards for those who donate larger amounts of money.

viewers can pledge their donations. The catch is that you do not get these donations unless you achieve the goals stated in your video.

All-or-Nothing Funding

Let's say you are a musician and you want to make a CD, that will cost about $4,000 dollars to produce. Your Kickstarter video might be some creative form of you talking about your music and maybe playing a song. You are allowed ninety days or less to raise money. If at the end of ninety days only $3,500 is pledged, the project's financial goal has not been reached and you will get nothing. The reason funding is all or nothing is so that the project actually gets done well. It also ensures that the donors' money will only be spent on successful projects. The key to any project on Kickstarter is to create interesting rewards for those who donate larger amounts of money. For example, all donors will receive a personalized thank you email from you; or those who donate $5 will receive an mp3 of one of your songs, $10 will earn them a copy of your CD, and $15 gets them tickets to one of your shows. The more creative and enticing your rewards are, the more likely people are to donate.

You as a Philanthropist

The easiest way to see how Kickstarter works is by exploring the website. You will see that most projects never get funded,

but the ones that do get funded all have promotional angles and good rewards that make them special. Try funding a few projects for a dollar to see how it works. In the case of non-visible art, we wanted the rewards to be the art itself. We thought we could make a video describing the museum and raise $5,000. The rewards would be descriptions of the non-visible art. For a certain donation amount, we might describe a painting of a horse in a field. That is what we wanted to do, but the challenge was deciding how to make the videos and promote the project.

Promoting the Project

The reason project promotion is so important is because if you just post something on Kickstarter and wait for pledges to come in, usually nothing happens. You have to tell your friends on your various social networks what you are doing. And if you are trying to raise a significant sum like $5,000 or more, you may even have to make calls. Promotion is something you must tackle and manage well. In our case, we began with deciding how to make our video. Since we didn't actually have anything to show we thought we should both talk about the museum. As we discussed that possibility, we also thought it would help to have someone else in the video who understands what we were planning to do.

James Franco

We thought James Franco would be good, as he has done some very high-concept artwork himself. We decided to email

him a short note inviting him to be in our video. The email was very brief, and there were no images or website link. We simply asked him if he would talk to us about being in our project. After a few days he wrote back, saying that his assistant would set up a meeting.

Arranging a Meeting

That meeting took over a month to plan, but he was and is a very busy actor and artist. Finally, we had a lunchtime meeting with him at a small cafe. He was dressed very casually and so were we. We only had about thirty minutes of his time, so after initial pleasantries, we told him our idea. We explained that if someone bought a piece of art, they would actually get a card in the mail with a description on it, which they could then put on their wall. If someone asked, or if the new art owner wanted to show the work, he or she could use the description on the card to talk about the art. James understood the idea and liked it. He told us that it made him think of film projects he has wanted to do, and maybe we could use those for our museum promotion. We liked that idea, and he told us about a film he wanted to make that never happened for several reasons. He agreed to make a five-minute video describing our museum and his movie project for our Kickstarter promotion. We were super excited.

Making the Video

After he made the video of himself describing the work, we edited it and submitted it to Kickstarter. A word of caution here: Kickstarter is not YouTube, and when you propose a

> E-marketing programs, of which there are many, are used to create signup forms on your website so people can join your mailing list. When they do this, their information is stored in a database and they will be included in future newsletters and updates. These programs are very important because you want to be able to collect contact information from potential customers who visit your site.

project to them they can accept or reject it. If your proposal gets rejected, as our first one (before MONA) did, don't lose heart. Try again and make your rewards more interesting.

When MONA was accepted, we began writing out our descriptions of the museum for our rewards. The following things we did to prepare the project for launch are things you need to consider for your own work, even if you are not fundraising or selling at the moment.

What We Want from Our Website

There are three things we want from our website viewers. We want their email addresses so that we can keep in touch and let them know about future projects; we want their financial support; and we want them to spread the word about our project on Facebook and Twitter. To help facilitate these activities, we made new webpages. One was for MONA, and the other was for Praxis, our general art page. Then we opened new Twitter and Facebook pages for Praxis. The next thing we needed was an e-marketing program.

E-marketing Program

E-marketing programs, of which there are many, are used to create signup forms on your website so people can join your mailing list. When they do this, their information is stored

in a database and they will be included in future newsletters and updates. These programs are very important because you want to be able to collect contact information from potential customers who visit your site. Artists' websites are usually a bit of a mess, with lots of old work, and typically a homepage that hasn't been updated in a while. I have an idea to solve this problem, a kind of web 2.0 artist homepage for the 3.0 world. And it's really much easier than current website models.

New Web Design with "Like" Buttons

The MONA website that I designed with my wife is very simple. There is some brief text describing the museum, and above are two widgets and a simple graphic of the acronym MONA. One is a Facebook widget that allows other people to "like" and share the website on their Facebook page. The other is a Twitter widget that lets them tweet about your website directly. The page also has a sign-up form which I keep extremely simple so that subscribers only have to enter their email and click the "Submit" button. Additional things like email verification and more personal information is unnecessary, and may discourage people from signing up.

Simple Signup Form

The sign-up form is super simple, even elegant, and there are no other photos on the site—just a link to the Kickstarter project. The website's simplicity is important because there is little to navigate, and just a few elements for sharing , so it works perfectly. People can read the entire page in less than a minute and they can post, like and tweet it without leaving the page. The only other thing they can do, also without leaving

the page, is sign up for the email list. You can still see the site by going to thenonvisiblemuseum.com. However, at the time of this reading, the site has been redesigned by the Saatchi & Saatchi, who did it for me pro bono, and incorporates much of what I just said above.

A New Artist Website, Too

Another similar site focuses on all the work I do with my wife (twobodies.com). You may already have your own site or are thinking of building one soon. Twobodies and MONA have similar web designs—few to no pictures, the same "like" and "tweet" buttons, a sign-up form, and some descriptive text—but the big difference with Twobodies was four large live-feed widgets which constantly update and displayed portions of my Facebook page. On Twobodies, these four rectangular widgets sit next to each other on the bottom of the page showing new information all the time. One of the widgets is a Kickstarter widget tracking the progress of the project, and others are for Facebook, Twitter, and Tumblr. Now, whenever I post something new to my social networking accounts, my Twobodies homepage updates automatically.

Networking All of Your Media

To summarize what I have said so far pertaining to networking, there are three things to keep in mind for your artist webpage. The first is the "like" and "send" buttons from Facebook and Twitter. The second is a signup form for your mailing list that you will get when you subscribe to a paid e-marketing service like icontact (which is what I use) or mailchimp, constant contact, patronmail or another, they are all the same more or less.

The third is widgets that will stream information from your Facebook and Twitter accounts, providing your page with constant updates. And, of course, you have to decide how to handle the text and image layout on your website. If you really want a lot of images on it, I would suggest embedding a slide show that you can easily update and doesn't unnecessarily clutter the page. Try to keep your text brief, and embed active links to essential information about you or your work.

All You Need Is Updates

That is really all you need to connect and automate your website to your social platforms. You can change the text on your website every now and then to reflect current news, but for most part the website will update itself using your widgets. There are several other sites which let you share and post information and you can always add new widgets to your website to include these as well, but I like a minimal look, as it makes content and aesthetic easier to maintain.

Clean and Simple Single Page Website

Pages that have minimal clickable buttons and links are nice because they are easy to navigate. Think of the Google homepage. It really only has one box, the Search Bar, that a user can interact with. I believe we all want our pages to be that elegant. Google is a good example of how less can be more on a website. I say this because I think that part of my project's success was due to how easy it was to share online. Our art website was not just minimal, it was easy to read, and because it was also interesting, people "liked it," shared it, and tweeted it.

News Media Design on the Web

Your webpage should have a similar design as that of an online news article. If you look at an article from the Huffington Post, or any other major online news publication, it only includes the article and relevant links embedded into the text, a few select photos, and "like" and "tweet" buttons at the top. Sometimes the all-inclusive "add this" button pops up to let you conveniently select which of the growing supply of networks you want to share the article on. The point is that these news sites are designed to be read and shared, and that's how your site should be as well. You want people to understand who you are, what your project is, and what things they need to click on your page in less than a minute. The simplicity of this model means there's actually less for you to do when you make your page. The hard part is having the restraint to not include unnecessary pictures and links.

In Summary

Let's summarize how I prepared for the MONA project on Kickstarter. I made a simple MONA website with a small text block and a few widgets. I also revamped my regular artist website with a similar look of minimal text, a few links, and the "like" and "tweet" buttons. Free from advertising and other clutter, my pages were clean and easy to navigate. My primary goal was not to share content, but to get many "likes" on Facebook, and most of all, gather more email addresses. The email signup form is incredibly important, especially if you keep it simple so subscribers need only provide their email addresses and hit *Submit*. Having this kind of email marketing service is very helpful. It allows all persons interested in your work to receive updated information from you in a single email blast. That is the basic skeleton and summary of what I did online, but of course to be successful I also had to consider the content of the MONA project and recruit James Franco. There are many steps to making a project like this successful and the best it can be, and we knew we wanted to broadcast it inside and out of the art world. James Franco was essential in achieving that goal because of his popular appeal, and his mind for art. He has a way of thinking and working with art that is similar to ours, and we knew he would communicate to casual and mainstream art observers as well as those outside the world of art. We were so happy that he liked our idea, and his contribution fit perfectly with our project, just as we thought it would.

The Kickstarter project for MONA ended on August 31, 2011. By the end it had raised $16,000, had 1,012 new subscribers on the email list, got 2,780 Facebook "likes," and got 165 project backers.

The Final Statistics

The Kickstarter project for MONA ended on August 31, 2011. By the end it had raised $16,000, had 1,012 new subscribers on the email list, got 2,780 Facebook "likes," and got 165 project backers. Those are pretty incredible statistics for a ninety day project. It also generated over forty articles in the press and James Franco promoted the museum on *Jimmy Kimmel Live*! The MONA idea was a good one, of course, but tools for generating that kind of success are clearly laid out in this book for anyone to replicate. I am grateful my project created with my wife worked so well, and that I could use it as an example in this book!

How to Use This Book as a Textbook for a Course on Professional Development for Artists

Notes for International Teachers and Students Using this Book in a Classroom

- How to adapt this book into a syllabus for teaching professional development courses in universities
- Notes on generating discussions and assignments
- Downloadable syllabus PDF document
- Course Structure

I consider this book a follow-up course to the first book I published, Making It in the Art World. That book had a syllabus for a college-level course, and there is also a syllabus for this

book which you can download for free as a PDF online. Since the content in this book concerns the latest digital platforms for social exchange, you will need the updated syllabus for new issues not covered in this book.

For the Teacher

You can use both books as textbooks in two different courses on professional development for artists. "Careers for Artists," "Income Strategies for Artists," "Professional Presentation for Artists," and "Artists in the Marketplace" are a few possibilities. You might also try something based more in economics such as "Professional Course Work to Earn a Living in the Arts," or "How to Get Funded and Stay Funded in the Arts." A fun, punchy title is sure to help increase enrollment, and it is important to pass on the information in my books to as many young artists as possible. As a class aid, you can also purchase a two-hour lecture on DVD to help you teach the course. It is called *Income Strategies for Artists*, and it is available on amazon.com. You can download a course syllabus at (http://yourartmentor/syllabusnewmarkets.pdf)

Notes for Teaching Anywhere in the World

The syllabus is adaptable and can fit any teaching model, world culture, or student education level. The course could also be taught to high school students, though it would have to be adjusted for their age and/or require parental consent to teach certain parts dealing with public exposure. It is best suited for undergraduate and graduate students who are interested in making careers of their art education.

Both books are geared toward helping the career artist who wants to supplement his art and artist lifestyle with jobs like teaching. Even if the student prefers academia to studio practice, this course can help him understand what artists must struggle with and overcome to maintain a successful career in the arts.

General Tone

When teaching the course, try to adopt a tone that encourages and supports your students. Many artists get discouraged in art school, either from withering critics or mean teachers, so try to be a teacher that builds their confidence and helps them break new ground. My books ask artists to innovate, so stress to your students that this book is meant to spring-board their artistic journeys. There are new technologies and online games all the time, and they can use them to experiment with the online strategies this book discusses. Students should leave your class feeling empowered and more confident in their ability to achieve their artistic goals with the tools the course has given them. All artists want to share their work with the world, and by using the very latest online sharing sites, your students can accomplish this, and can even teach you how to use new technologies that you might be unfamiliar with.

Be Inspiring

As best you can, try and be the kind of inspiring teacher that movies are made about. Promise your students something unimaginably great that they can achieve with hard work and persistence. A wonderful example is John Keating (played

by Robin Williams) in the movie *Dead Poets Society*, who famously said "'Carpe diem.' Seize the day, boys. Make your lives extraordinary." This book can be used to inspire and build confidence so your students can go on to open doors that will help advance the entire art community.

Ask the Students

If your students want to talk about a certain aspect of the art world, encourage them to explore it and use the resources in this book as a starting point. Many of the exercises in the syllabus involve writing and researching, so it is always possible to do more if the interest is there. For example, many students probably want to talk about galleries and representation, even if there is a multitude of other options to choose from. If that is the case, then you should thoroughly discuss galleries so your students can present themselves professionally when the time comes. And you should have them do real market research by asking local galleries about how artists should approach them with their projects. See what happens as your class advances through the semester. Of course, there is more on market research and approaching galleries in the first book, *Making It in The Art World*.

Presentation and Research

Students may also want to focus on portfolio development and the question of how to present their artwork. If so, ask them to research the matter on their own, not just with a computer, but by making phone calls as well. One of the most essential skills of becoming a career artist is being outgoing enough to put yourself out there and create new relationships. It's not

easy, but it is important to go beyond merely sending emails and instead converse with people more directly so making phone calls and talking in person should be

> *If you are a student or a career artist, this book can help in a few ways. You can be both teacher and student by downloading the syllabus and doing the exercises associated with this book.*

a requirement for your students' research projects. They can call gallerists and museums—domestic or international, it doesn't matter. The idea is to get students away from books and computers and onto the street where they can meet people who can help them. I cannot stress this enough. Artists must get out of their studios and talk to others about their work and build relationships whenever and wherever they can. Teachers and students can also check my website (yourartmentor. com) and receive more up-to-date information through my newsletter and other online resources.

For the Student

If you are a student or a career artist, this book can help in a few ways. You can be both teacher and student by downloading the syllabus and doing the exercises associated with this book. That should get your creative juices flowing, but if not, the book has other uses. You can read it at your own pace and stop to try ideas that interest you anywhere along the way. The book's purpose isn't so much to follow a specific plan, but to inspire you to make your own plans based on what you already know and love. Beyond the chapter on how to manage your time and handle the daily grind, you need to be inspired and disciplined enough to follow through with whatever you start.

Syllabus to Adjust and Use for an Academic Course

I have listed below some of the topics that should be discussed in a class based on this book. You also can spend time discussing and looking at online examples of the latest presentations artists are making with through Facebook and their own websites.

1. Discuss social media from Twitter to Facebook

A. Find out what platforms your students are using, how often, and how helpful they have been.

B. Discuss and demonstrate how computer programs and services work. Teach them how to make Twitter or Instagram accounts, and open the conversation up so that students can also discuss other sharing sites that you might not know yourself.

2. Passwords

A. Passwords are one of the most important things in the book which people often ignore. Show your students how to protect their online accounts by giving examples of strong passwords and compare them to weak or commonly used passwords. You can get a list of commonly used passwords by typing "commonly used passwords" into an online search engine.

B. Talk about identity theft and how serious the consequences can be. Give examples. Personal stories will have the strongest impact, but you can read other people's horror stories online.

C. Stress the importance of secure passwords, because weak passwords are liable to be cracked, and if that happens a person's life (and potentially their

friends' as well) can be severely complicated and compromised.

3. Social Media Exercises

A. Look at online games and discuss the most popular ones.
B. Poll the class to see what games they play the most.
C. Come up with new ideas for gaming, or have everyone make a quiz for their friends on Facebook to take.

4. eBay and Kickstarter

A. Read and talk about Abbey Ryan and TMNK. Both artists have sold work on eBay.
B. Discuss and look through past projects by artists on Kickstarter.

5. Studio Visits and Parties

A. Discuss how studio visits work after reading that chapter.
B. Discuss what a studio party is and how it works.
C. Ask your students to host their own visits and parties and for the rest of the class to attend.

6. The Next Media, New Frontiers

A. Discuss the latest apps and platforms for communication, and what their potential is.
B. Review how the growing number of new online sharing services has increased the frequency of how often artists must change how they present their art.
C. Brainstorm the newest advances and talk about how they are affecting visual culture.

7. Art Consultants

A. Discuss the different categories of consultants.
 1. Introduce coaches and mentors (like the author of this book) and explain when and how to approach them.
 2. Introduce buyers for interior designers, corporations and other commercial clients and explain when and how to approach them.

8. Art Fairs

A. Name the current major fairs in the world and familiarize your students with them.
B. Get the fairs' latest sales and attendance figures.
C. Discuss how to get into small fairs, big fairs, and renting space near a fair. Explain the pros and cons of small and big fairs.

9. MONA, the Non-Visible Museum Story

A. Read and discuss the MONA story.
B. Ask the class if they would do the project differently.
C. Discuss why they think this project worked so well.

Index

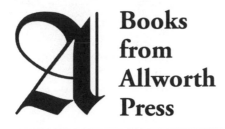

Books from Allworth Press

Making It in the Art World
by Brainard Carey (6 x 9, 256 pages, paperback, $24.95)

Selling Art Without Galleries: Toward Making a Living From Your Art
by Daniel Grant (6 x 9, 288 pages, paperback, $24.95)

The Artist's Guide to Public Art: How to Find and Win Commissions
by Lynn Basa **(6 x 9, 256 pages, paperback, $24.95)**

Guide to Getting Arts Grants
by Ellen Liberatori (6 x 9, 272 pages, paperback, $19.95)

The Profitable Artist: A Handbook for All Artists in the Performing, Literary, and Visual Arts
by Artspire (6 x 9, 256 pages, paperback, $24.95)

Starting Your Career as an Artist
by Angie Wojak and Stacy Miller (6 x 9, 288 pages, paperback, $19.95)

The Business of Being an Artist, Fourth Edition
by Daniel Grant (6 x 9, 408 pages, paperback, $27.50)

Fine Art Publicity: The Complete Guide for Galleries and Artists, Second Edition
by Susan Abbott (6 x 9, 192 pages, paperback, $19.95)

Legal Guide for the Visual Artist, Fifth Edition
by Tad Crawford (8 ½ x 11, 280 pages, paperback, $29.95)

The Artist-Gallery Partnership, Third Edition
by Tad Crawford and Susan Mellon (6 x 9, 224 pages, paperback, $19.95)

Business and Legal Forms for Fine Artists, Third Edition
by Tad Crawford (8 ½ x 11, 176 pages, paperback, $24.95)

Art Without Compromise
by Wendy Richmond (6 x 9, 232 pages, paperback, $24.95)

How to Start and Run a Commercial Art Gallery
by Edward Winkleman (6 x 9, 256 pages, paperback, $24.95)

The Artists Complete Health and Safety Guide, Third Edition
by Monona Rossal (6 x 9, 416 pages, paperback, $24.95)

Learning By Heart
by Corita Kent and Jan Steward (6 ⅞ x 9, 232 pages, paperback, $24.95)

The Quotable Artist
by Peggy Hadden (7 ½ x 7 ½, 224 pages, paperback, $16.95)